# Re VIEWS

## Artists and Public Space

Re

# VIEWS

## Artists and Public Space

Black Dog Publishing

# Contents

Previous
Alison Turnbull, *Moon* (detail),
1999, graphite and ink on
concrete, Milton Keynes
Theatre

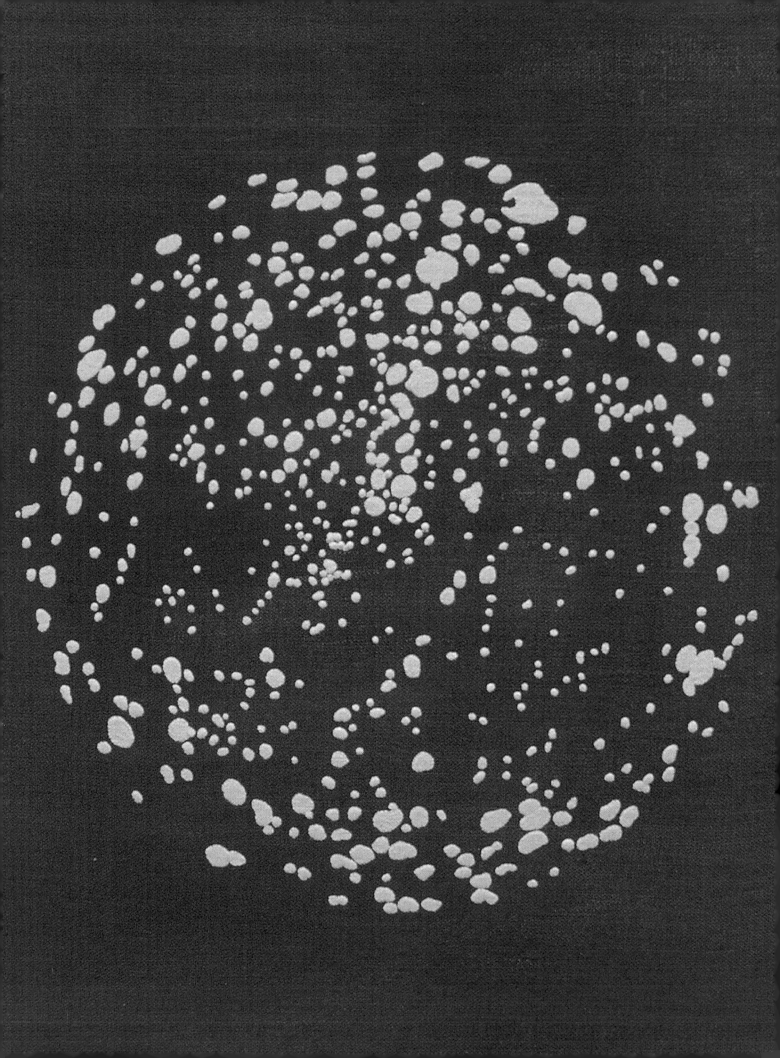

# Foreword

## Sir Christopher Frayling
## Chair, Arts Council England

By concentrating on the experiences of various artists who have successfully completed projects in public spaces, this book literally breaks new ground. There have been books about specific projects or commissioning agencies, usually with lots of glossy photographs. There have been academic studies and even 'how to commission it' guides. But, so far as I know, there has never before been a book which concentrates on the processes and outcomes of public art *from the artists' point of view*.

So *Re Views* is about a repertoire of new roles for the visual artist in the early twenty-first century: as curators, consultants, researchers, teachers, designers, animators, stage managers and of course as artists. The more traditional roles of the artist, in studios and workshops and galleries, step out of the spotlight to allow artists working in public spaces to take centre stage.

The book has been published to celebrate the tenth anniversary of Artpoint, a commissioning agency which works with artists in (though not necessarily from) the South East of England—together with public and private sector partners—to create temporary and permanent works, events and residencies. It revisits ten projects from a variety of perspectives, including research, education, collaboration, and the design of public spaces; hence the title. It is about the special kinds of professionalism which are needed when artists work in public spaces.

Alison Turnbull, *Untitled (Moon)*, 2000, acrylic and enamel on canvas

# Preface
## Ruth Charity
## Assistant Director, Artpoint

Artists contribute to our perception and experience of our environment in many ways, not only by creating individual artworks, but by collaborating with others to influence the architecture, public spaces and landscapes we inhabit, and developing creative ways of engaging people of all ages in re-visioning their environment. At the beginning of the twenty-first century, artists are not only being employed as makers of objects but are increasingly working in new roles, for example, as consultants on large scale projects—from major regeneration schemes to the masterplanning of new areas of housing and development. Artists are being invited to use their understanding of space, form and colour to consider the development of architectural forms as well as the planning of towns and cities, from transport systems to the design of public squares. They are being asked to use their critical, conceptual skills to contribute to dialogue and discussion on the future of our shared spaces.

Artpoint is a visual arts commissioning agency that has been working with artists to create new artworks, interventions, responses and collaborative projects for public spaces since 1994, building on the success of City Gallery Arts Trust from which it evolved. The idea for this book was to celebrate over a decade of the organisation's work through examining the different ways in which artists are impacting on our public spaces today, as well as exploring the effect of public work on the development of artists' own creative practice.

*Re Views: Artists and Public Space* is introduced by two essays. Louise O'Reilly, Artpoint's Director, reflects on what motivates artists to work in the public sphere, and considers what really constitutes 'public space'. The artist Edward Allington contemplates the sliding definition of 'public art', its parameters and authors, and advocates the importance of taking pleasure from our visual experiences.

*Re Views* considers ten different approaches employed by artists working in public contexts. Each approach is illustrated through a particular case study or commission, selected to include artists at different stages in their profession—from early career to established figures; working with a range of media—from sculpture, glass, light and sound to photography, projection and installation; and including those from fine art, craft, design and socially engaged practice. Our intention has been to focus on the artist's experience of taking their practice outside the studio and gallery. Each artist has been invited to write a response to the commission, outlining their experience of the project and considering its impact on the development of their work. Each artist's text is followed by that of a commentator—a writer, fellow artist, curator, architect or urban design professional—who discusses the project in the context of its overarching theme and reflects on its effect and impact.

The restrictions and possibilities offered through public commissions often encourage artists to experiment with new ways of working, whether by using unfamiliar materials, working on a different scale, responding to a new environment, or being stimulated to take a new approach to their work through discussion and dialogue with professionals from

other fields—whether an astrophysicist, an architect, or structural engineer. Artpoint has always endeavoured to support experimental working, encouraging artists to push their practice in new directions and take on collaborative projects. As part of the genesis of this book, Artpoint, in partnership with the Slade School of Fine Art, University College London developed a project to encourage artists to research and test new media. The ten artists featured in the book were offered the opportunity to create a limited edition print, using the Slade's digital printer, a technology unfamiliar to many of them. We are indebted to Edward Allington for originating this project and, together with John Aiken, Klaas Hoek and Denis Masi at the Slade, enabling it to happen, and to Finlay Taylor who gave invaluable support to the artists in their creation of the prints with the assistance of James Keith. Each artist's print is reproduced at the end of the section on their work.

This book could not have been produced without the support and help of a large number of people. We should like to thank all the artists for sharing their experiences and providing such a fascinating range of insights into their individual working practices, and for all their help throughout the process of developing the book. We are also very grateful to all the writers who have offered new perspectives on the artists' work, providing thoughtful and considered essays which eloquently complement the artists' own words. Not least, we should like to thank all the other artists and partners with whom Artpoint has worked, who have formed part of the organisation's cumulative experience, but who could not be included here.

*Re Views* has been developed in collaboration with Artpoint's staff, whose skills, experience, creativity and imagination have not only contributed to the book but also to the projects featured within it. We are very grateful to our publisher, Black Dog, in particular Duncan McCorquodale for his thoughtful editorial comment, and to Amy Sackville for her careful copy editing. The clean and elegant design of the book is the work of Alan Ward, whose intelligent use of images has done ample justice to the artists' work. I could not have done my job as editor without effective support—the complex work of picture research has been undertaken with calm efficiency by Sandy White and Tigger MacGregor, who, together with Pauline Heffernan, provided vital administrative assistance. Finally, I should like to extend our thanks to Arts Council England, South East, without whose financial support this book would not have been possible.

Bruce Williams, directional signs, 1995, laser-cut steel, Genito Urinary Medicine Clinic, Leicester Royal Infirmary

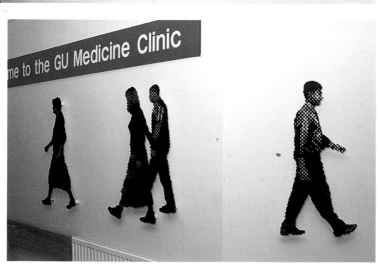

# Found in Translation
## Louise O'Reilly
## Director, Artpoint

### Leicester Royal Infirmary, 1994

In 1994 the Leicester Royal Infirmary opened a new clinic for genito urinary medicine. It was bright and clean, and smelt of fresh paint and disinfectant. Recessed fluorescent tubes filled the corridors with constant, shadowless light. The walls were white, or almost white, and the corridors infused with quiet noise—humming machinery, lowered voices, rubber soles on safety flooring. To enter the new clinic was to travel from a huge, labyrinthine building into a more intimate space. Left behind was a riot of signals and symbols (lifts, signs, corridors, people, colour, soft furnishings, Monet's ubiquitous poppies) with their contrary invitations to find your way, trust in the hospital's clinical care and feel right at home.

Beyond the swish of the automatic glass doors, however, the clinic had two problems, one practical and one aesthetic. The practical issue was how to direct patients and visitors to the correct part of the clinic, which included a male clinic and waiting area, female clinic and waiting area and a mixed waiting room. Text based signage was inappropriate as many patients did not speak English and the range of languages was too numerous to list. A foray into symbol-based design led to a proposal that punctuated the department with little plastic men and little plastic women and suggested, more than anything else, a public loo. Which leads to the aesthetic problem. "You see", the consultant gynaecologist explained, "we deal mainly with patients with sexually transmitted disease, particularly HIV and Aids, and one of the challenges for the department is to help people overcome a sense of taboo about their illness, so... um... the icon based signs weren't giving out quite the right, well, the right... 'ambience' shall we say."

Faced with this functional, spatial and semiotic dilemma the clinic realised they needed a different kind of specialised help. They needed an ideas person, a lateral thinker, an originator, an outsider, a creative problem solver, someone with a new vision, who would ask different questions, who would come up with an inspired solution, who could create something both functional and maybe even beautiful. They needed an artist.

A commission brief was developed for a series of artworks that functioned iconographically but also avoided stereotypical references to sex, age, gender or race; works that must meet specific functional requirements and create an aesthetic that improved the human experience of the space; works that must comply with a host of physical and safety constraints and not exceed a modest budget. The department looked at work by artists who dealt with health, gender and diversity issues; who were interested in figurative representation as well as codes, signs and iconography; who were working in appropriate materials to meet the need for durability and two-dimensionality. They elected to commission Bruce Williams. His solution was imaginative, deft and practical. Working from the premise that if you provide signs of people walking in certain directions people will intuitively follow them, he photographed staff from the clinic walking. The images were digitally manipulated to produce a stylised template, which was then laser-cut in steel. Each sign was of a different individual working in the department reflecting a diversity of age, gender and race.

As the commission progressed, two considerations struck me. First, how much we need and want from artists, and second, what is in it for them? I asked Bruce. His immediate reply was "A new Apple Mac and the opportunity to use the medical illustration department as a studio, their photographic equipment was fantastic!" One interpretation of this response was that the commission was a successful transaction. Another, that the opportunity to buy the latest Macintosh computer for an artist working digitally signified the opportunity to open a new chapter in his creative exploration.

## The Monument, London, 2004

The inscription on the south side of the Monument in the City of London, designed by Sir Christopher Wren and Robert Hooke to commemorate the Great Fire of 1666, reads as follows:

> Charles the Second, son of Charles the Martyr King of Great Britain, France and Ireland, defender of the faith, a most gracious prince, commiserating the deplorable state of things, whilst the ruins were yet smoking provided for the comfort of his citizens, and the ornament of his city; remitted their taxes, and referred the petitions of the magistrates and inhabitants of London on the Parliament; who immediately passed an Act, that public works should be restored to greater beauty, with public money, to be raised by an imposition on coals; that churches, and that the cathedral of St Paul's should be rebuilt from their foundations, with all magnificence; that bridges, gates and prisons should be new made, the sewers cleansed, the streets made straight and regular, such as were steep and levelled and those too narrow made wider, markets and shambles removed to separate places.

The Monument opened in 1677, a surprisingly sprightly 11 years after the fire. When completed it created a towering landmark rising high above the city. Moreover, it was a visitor attraction, providing a public viewing platform of the metropolis below. It created a new experience of the city as spectacle, revealing the regeneration (as we would call it now) as a sort of performance of urban progress.

Today the Monument has lost its dominance in the cityscape. It is almost hidden amongst the office blocks that have long replaced the elegant Regency square that once enclosed it. The Monument no longer offers a unique and thrilling panorama of the city. Views just as sensational are commonplace from corporate, plateglass windows and social housing blocks throughout the city. One feels pathos now looking out from the Monument, to see the new kids on the block drawing in the crowds to watch the theatre of the city: the London Eye, Tate Britain, and the 'Gherkin'.

Unlike its competitors, however, the Monument is uniquely linked to the shaping of the place where it stands. To visit it now is to enter a kind of time machine for the city. To climb the worn, stone, spiral steps in the damp, cramped interior is to step in the footsteps of previous generations, to re-enact their experience. The Monument evokes its former glory and walking out onto the 360 degree viewing platform one is almost surprised not to see a Stuart city stretching out below. The contemporary experience of visiting the Monument suggests a city changing over time. We see it not just as it is now but also as we imagine it 300 years ago. We might also wonder how it will be in 300 years' time. The Monument reminds us that places exist as much in our memories and imagination as in our sensory perception.

Given this grand historical context it is striking to read the inscription and find a surprisingly contemporary message. For "commiserating the deplorable state of things" read "decline of our inner cities"; for "comfort of his citizens" read "social inclusion and community participation"; for "the ornament of his city" read "design standards and

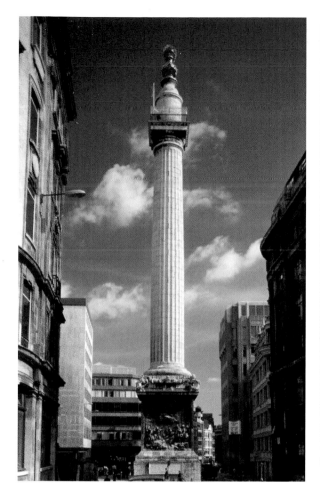

Christopher Wren, *The Monument to the Great Fire of London*, 1677. Reproduced courtesy of the Corporation of London

Caius Gabriel Cibber, drawing for bas-relief on the base of the Monument, depicting King Charles II 'affording protection to the desolate City of London and freedom to its rebuilders and inhabitants', 1677. Reproduced courtesy of the Corporation of London

cultural regeneration" and for "remitted their taxes" read... well, "remitted their taxes". In place of King Charles II expressing a reforming zeal for the city we have Rt Hon John Prescott and his Sustainable Communities Plan. Sure, the fashions have changed. The new vision of the 1770s was to rationalise the street plan and sweep away the markets and the shambles. Today a key design principle of the major redevelopment of Paternoster Square, adjacent to St Paul's Cathedral, was to re-instate the medieval street plan. *Plus ça change, plus ça reste la même.*

There is a danger of stretching this analogy too far. The urban design and environmental issues we face now would have been incomprehensible to the Court of King Charles II, and the landscape of 300 years in the future will similarly be shaped by forces and knowledge we cannot begin to predict. However, the inscription does uncannily describe characteristics of regeneration recognisable today; state intervention, public funding, a motivation to improve the quality of life for the public, an aspiration for places to succeed both aesthetically and functionally—for beauty, ornament and decent sewers. Perhaps there are parallels too with recent political commitment for urban renewal and the present sense of urgency about the pressures facing our environment. Our capital city may not have burned to the ground but shaping our spaces both for now and for the future poses challenges no less fundamental. The UK government has just announced plans to build 1.1 million new homes by 2016. Global warming is subtly amending our ecosystem. The World Wide Web has revolutionised business and domestic communication in a mere ten years or so. Some predictions suggest a doubling in car use world-wide in the next 25 years. The rise of the global corporation has dwarfed the financial independence of many states and increasingly homogenises our urban centres through the ceaseless multiplication of chain stores and global branding.

How well are we equipped to meet these challenges? How do we make this place, *our* place, succeed on its own terms and be viable within a global culture and economy? How do we address the spaces and places in which most of us live? Places that aren't great or beautiful but are commonplace suburbs and dormitory towns. Where will we find the sheer imagination and chutzpah to understand the nature of the questions themselves, let alone discover meaningful answers?

Too often such issues are perceived through lenses of practicality and solutions sought through functional processes alone. Richard Florida, Hirst Professor of Public Policy at George Mason University in Washington, advocates a different approach. His thesis, developed over years of studying technological innovation and regional development, is that creativity is *the* principal driving force in the growth and development of cities, regions, and nations; as he has asserted in numerous interviews, seminars and lectures:

> Without diversity, without weirdness, without difference, without tolerance, a city will die. Cities don't need shopping malls and convention centres to be economically successful; they need eccentric and creative people.

This statement calls to mind Wendy Cope's satirical lament published in response to an advertisement in *The Times* by the Engineering Council asking why there wasn't an Engineers' Corner in St Paul's Cathedral.

> We make more fuss of ballads than of blueprints –
> That's why so many poets end up rich,
> While engineers scrape by in their cheerless garrets.
> Who needs a bridge or dam? Who needs a ditch? ...
>
> ... No wonder small boys dream of writing couplets
> And spurn the bike, the lorry and the train.
> There's far too much encouragement for poets –
> That's why the country's going down the drain.[1]

Just as the Monument reminds us that we understand public space through our imagination as well as our senses, Cope reminds us that we understand it through other people's imaginations and senses too. It is impossible now to think about the Lake District without William Wordsworth, or visit Hull without the accompaniment of Philip Larkin's wry, regretful narrative. We cannot see New England without also seeing Edward Hopper, or Salford without hearing the clogs on cobbles of LS Lowry's factory workers. Each of us will have a different register of imaginative interconnections, some we'll recognise, most we won't, but they are potent and compelling nonetheless.

## A Place Between

This issue of asking the right questions in understanding public space is a concern for social geographers Professor Doreen Massey and Professor Gillian Rose at the Open University. They are currently engaged in an enquiry into how artworks within the city of Milton Keynes, a New Town that has involved artists in its 40 year development, function in public space. In a working paper "Personal Views: Public Art Research Project" they state their first priority is to conceptualise notions of place and public rather than singling out the significance of artists as actors in this realm.[2] Massey and Rose suggest that traditional concepts of place as bounded, essential in character, coherent and unchanging have no basis in real life, where place is better understood as open, diverse, complex and continually under construction. They argue that place is a combination of relations between people, and between people and the material environment, in specific locations.

1 Cope, Wendy, *Making Cocoa for Kingsley Amis*, London: Faber & Faber, 1986, p. 13.

2 Massey, Doreen, and Gillian Rose, "Personal Views: Public Art Research Project", working paper, 2003. Available from www.artpointtrust.org.uk or from the authors, Social Sciences Faculty, Open University, UK.

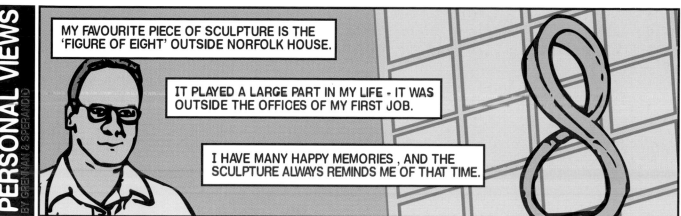

**AS TOLD TO THE ARTISTS BY BRIAN BARTON**

Grennan & Sperandio, *Personal Views*, one of a series of comic strip postcards created by the artists in collaboration with Milton Keynes residents, 2001-2, an artists' project that paralleled Massey and Rose's academic research

3 Massey and Rose, "Personal Views: Public Art Research Project", p. 5.

In a place such as a city or a neighbourhood... the various constituent spaces are not just containers within which people live out their daily lives. It is the living out of these daily lives which is itself part of making space....[3]

Likewise, whether a space can be considered public or not, is not predicated on whether people are permitted open access to it, but on the extent to which they actively engage with one another when there. For Massey and Rose public space only genuinely exists when social interaction goes beyond the passive (nodding acknowledgement in passing, holding open doors for one another) and becomes active (a public meeting or community event), and when individuals have to negotiate their social differences in order to engage with one another. Furthermore, it is in this social interaction that public space exists, not in the three-dimensional, spatial environment in which it happens.

An example might be Trafalgar Square, known more, perhaps, as a place for public meetings and demonstrations than for Nelson's column or Landseer's lions. For Massey and Rose, the poll tax riots of 1990 *were* the public space rather than the stone and mortar underfoot. The idea of public space understood as a riot illustrates other aspects of Massey and Rose's approach. That public space is provisional, temporary, fractured, complex and frequently conflicted.

There is strong resonance here with artists' practice that might be called socially engaged. Jeremy Deller's *Battle of Orgreave*, 2001, for example, saw members of the public and historical re-enactment societies, recreate the clash between striking miners and police in 1981. The event, as with all Deller's work, was documented, in this case by a film directed by Mike Figgis for TV, which, since Deller won the Turner Prize in 2004, is enjoying something of a revival at art house cinemas and conferences. Deller insists that his art exists in the events themselves and that the evidence of these events is just that, evidence. There is some common territory here with Massey and Rose. Their conception of public space exists through the negotiation of social difference. Deller's art is similarly temporal, it exists in the experiences of people taking part in a communal event.

### Artists and Public Space
In the same year as the *Battle of Orgreave*, artists Andy Hewitt and Mel Jordan created *Go Betweens*, a temporary work that developed out of a residency in the planning department of Congleton Borough Council. Concerned about the lack of public understanding of major redevelopment schemes about to radically reshape the town, the artists painted the plans directly onto the urban landscape. The work was a visual intervention into urban space,

Jeremy Deller, *The Battle of Orgreave*, 2001. An event commissioned and produced by Artangel

literally a drawing on the townscape, and a catalyst to evoke communication with and between local people about their environment. Hewitt and Jordan described their role in this process as ambivalent, "On the one hand we were acting as unofficial representatives of the Council. On the other, there was an implicit critique of the limitations of the Council's public consultation processes in the work." For Jordan and Hewitt it is their job as artists to be critical, it's a social responsibility and it's a very positive thing.

Gordon Young, consultant artist for the redevelopment of Blackpool's waterfront, a role he was invited to undertake by the Chief Planner, puts it more directly, "My job is to be a spanner in the works". Young describes a process of negotiation between planners, landscape architects, architects and engineers that is hectic, challenging, rapid, frustrating, dynamic, occasionally brilliant and often brutal. A good meeting seems to be one where tempers fray.

The projects discussed in this book describe artists' responses to, and interpretations of, places and communities that are minutely observed and impeccably place-specific. Massey and Rose observe that there is a great temptation to define 'art' in clear and certain terms.[4] But you only have to juxtapose contradictory definitions of art such as Immanuel Kant's universally recognised beauty to Pierre Bordieu's socially determined categories of cultural capital to demonstrate the impossibility of definition. Picasso had a good line on this that goes something like, "Why are we always trying to reduce things by defining them, as if it were not the job of the artist to constantly invent anew?"

But why claim any special sophistication for artists in understanding public space as opposed to architects or engineers, say, who are specially trained, or anyone and everyone, for that matter, who is qualified by lived experience? Well it is and it isn't to do with

4 Massey and Rose, "Personal Views: Public Art Research Project", p. 12.

qualifications. To be an artist is to accept that the very label you attach to yourself is provisional, temporary, fractured, complex and frequently conflicted. I venture to suggest that some level of consensus exists about what an architect is, or an engineer, and that consensus is linked to training, subject matter and role. I venture, too, to suggest that the worldview of architects and engineers is in some way formed and influenced by their professional discipline. But artists? Artists are aesthetes, Renaissance men, heroines, dilettantes, visionaries, romantics, grafters, activists, gurus, con-artists, *enfant terribles*, martyrs, populists, manipulators, agitators, voyeurs, media savvy celebs, *agent provocateurs*, makers, thinkers, speculators, rebels, mavericks... I could go on. Artists survive in the chaos of myth and stereotype surrounding them because of a single-minded determination to pursue a particular line of enquiry, because they are self-validating, because they not only develop their own work but their own methodologies, because they invent themselves, because, I suppose, they don't care about labels, they care about art.

### Brief Encounters, Slow Cooking

I'd like to return to this question of what's in it for artists. In September 2004 we invited the artists contributing to this book to lunch and put this question to them. I had contradictory expectations of the responses this might elicit. On the one hand, was it tantamount to asking what the Romans did for us... so, what's in it for you, other than opportunities, new relationships, resources, budgets, audiences, profile, media attention and fees? On the other hand, would it lead to an afternoon of grumbling about unreasonable commissioners, greedy sponsors, unrealistic public expectation, small budgets, ridiculous timescales, scathing contractors and taking the flak from retired generals? Of course nothing so polarised or consistent emerged but a few themes did.

Top of the list was relationships. The artists considered the opportunity to explore new relationships and embark on interesting dialogues to be of paramount importance, and the chemistry between people to be more important than compatibility of work. What mattered was finding something interesting to talk about and being able to continue that conversation, indefinitely and at a leisurely pace.

Andy Hewitt and Mel Jordan, *Go Betweens*, 2001, water-based spray paint, Sandbach

It was interesting to hear artists describe the process of de-coding the subtext of a project or public context before deciding whether to jump in. So much about working in public space is built on faith and trust. Of course, in all situations there are influencing factors, both spoken and unspoken. But for artists working in public spaces these are perhaps particularly loaded, partly because of the preconceptions we all cling to when it comes to art and artists, and partly because art does seem to matter even to those who profess a lack of interest. I submit as evidence for this Tate Modern's inspired preview of their new displays held for London cabbies even before the art glitterati were allowed through the door. I watched on television as a shuffle of sceptical, no-nonsense blokes spread through the galleries exuding an attitude of almost universal mockery-cum-outrage. Gradually they dispersed and individual reactions could be observed. One chap hovered around an Anthony Caro sculpture and, when prompted, said, "I didn't expect to find anything I liked, but I like that. I don't know why but I like it.... Of course, the rest of it's a load of old rubbish!" He walked away roaring with laughter, perhaps at his own sense of gullibility. But for a while and completely unexpectedly he had experienced something approaching a passionate response to a work of art.

It is perhaps self-evident that for artists working in both, the boundary between studio practice and public space is extremely blurred. For John Kippin, public space is his studio; the so-called studio, a place for dissemination, not production. For Simon Read, his practice as an artist has become indistinguishable from active citizenship. At the centre of Peter Randall-Page's practice is a studio in the more traditional sense, but as Roger Deakin observes in his essay, the studio, sculpture and sites where Peter works are all very similar. There is no consistent model of working, just passionate interests and an appetite to cross disciplines.

There were a couple of currents in the conversation that kept surfacing and occasionally merging, and which in retrospect I can only describe as experiences of 'brief encounters' and 'slow cooking'.

The 'brief encounters' were those serendipitous moments when something clicks and treasure is discovered, like the first meeting between artist Jacqui Poncelet and architect Dominic Williams. The latter introduced his architectural philosophy as a sort of neo-modernism, respecting truth to materials. "But materials lie, they lie all of the time!" exclaimed Jacqui, an artist whose practice began with ceramics, the most mimetic of all materials. From that moment it was clear that this conversation was going to be fun and interesting and enduring. Or between virologist Dr William James and artist Catherine Yass, discovering that their respective working methods used exactly the same colour blue to signify meaning in visual images. Or the encounter described on a postcard from artist Gordon Young after a research visit to the Rutherford Appleton Laboratory in Oxfordshire, "Stop Press! Had a fantastic day, indeed one of the most interesting days in years, it was that good... plus I got a sniff of another lead."

That "sniff of another lead" hints at the other theme, 'slow cooking', that approach to cuisine that isn't about posh ingredients, complicated skills or expensive equipment but simply about allowing a combination of flavours, textures and temperatures to mix and improve over time. And the thing about slow cooking is there is no other way to achieve the delicious results but over time. You just have to wait.

For artists working in public space this means time to reflect, have ideas and reject them, time to discuss, time to look and visit and experiment, time to learn. With respect to Tony Blair, it is all about Research, Research, Research! Simon Read's residency on the Thames Path in 1994 was a bold move at the time. His brief was simply to research; the only expected outcome was a research document. His relationships with the river, its

Thomas Eisl, *At Thames Times*, four photographs from an artist's book, 2000

communities and the discoveries he made during that time have been slow cooking ever since. Like a good whisky the longer it ferments the more sophisticated and satisfying the results. Around the mid 1990s artist Thomas Eisl was also commissioned to spend a research period along the Thames. In the early 2000s a wonderful artist's book arrived out of the blue. We had expected it some years earlier but it took a while for the ideas to fall into place.

In a way *Re Views* is slow cooking too; an opportunity to reflect on projects that occurred over a ten year period, sustain some of those conversations, consider what ideas these experiences germinate for the next decade. Ten years on from the Leicester Royal Infirmary commission we are working again with Bruce Williams, now as lead artist on a Private Finance Initiative project for seven new schools in Swindon. We are still talking about the legibility of environments and how the imaginative input of artists can provide a conduit for better communication between people and places and *vice versa*. This time the conversation includes a large constituency of young people. I'm looking forward to hearing what they have to say.

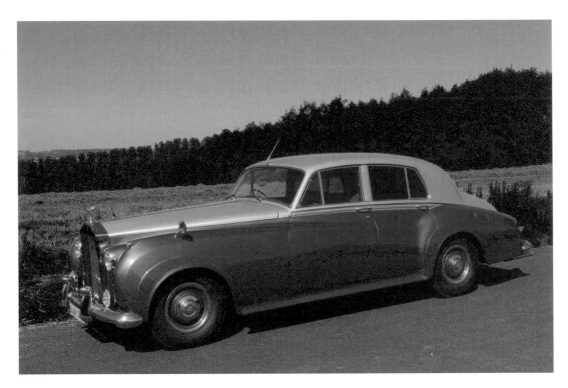

A Rolls Royce Silver Cloud

# For Your Pleasure or notes on public art from someone else's memory of a Silver Cloud in Wales
## Edward Allington

We were having dinner. There was wine, there was meat on the plates, boiled potatoes and fresh lambs lettuce in a bowl in the middle of the table. It looked beautiful, green, just washed and shaken with small droplets of water clinging, glistening on the leaves in the candlelight. I was at a curator's house in Germany and they were being very nice to me. One fragment of the conversation we enjoyed over that meal has stayed with me like an icon. We were talking about how the word beauty seemed to have fallen from use in relation to contemporary art. Then her husband described a scene he had witnessed when he was on a student walking holiday in the Welsh countryside. "Silently", he said, "it appeared from behind a hill on the road, a Rolls Royce; it was beautiful, it was like being passed by a cathedral."

He wasn't using the word beautiful to describe art either, but it started a different train of thought for me. I'd never thought of cars as being equivalent to cathedrals, but he was right, they are. They are like a constant stream of astonishing moving buildings, and in the same way as we will never know the names of the stonemasons, artisans and labourers who made the great European cathedrals of the Middle Ages, we will never be able to trace the myriad human hands that worked to produce all these cars. We might know the brands, or even the designers, but not the millions of people involved in mining the raw materials, manufacturing the plastic, the fabric and the countless parts from which they are made. This is the thing we always forget: virtually everything around us has been made, someone somewhere made almost every little bit of it. The world is a product of human labour and that includes rather more of the natural landscape than it should do. Someone made all the art around us as well, someone organised how it would come into being, someone made the materials, someone decided why, someone found the money to pay for it, and someone worked out exactly how it would look. We usually call this person the artist. Sometimes the artist makes it themselves, sometimes not. One thing is for sure: artists don't make art by themselves. Art is a social activity, and in that sense, the works of art around us are no different really than all the other things which we are all involved in, as we continually labour to remake the world.

Now the interesting thing for me, in thinking this through from a 'Rolls Royce rolling through the hills' point of view, was the recognition that, as an artist making work, writing, teaching, working with arts organisers and just being generally involved in contemporary art, I was just too close to see how anonymous it all is to most people. I have to say this realisation made me very happy, and this was not just because of a good meal, good wine and talk about Rolls Royces, which are very fine cars in my book. We tend to think of art as special, which in fact marginalises it as an activity; but art in public is actually part of the extraordinary ever-changing complexity of contemporary life.

Some cars, luxury cars in particular, cost more than most works of art; despite this cost, most of them are destined for the scrap heap, and the same thing goes for art too. We like to think we have a private life, but actually we live most of our lives in public spaces. I think the best way to think about the notion of public art is much the same: some

of it remains in private domains, but all the art you or I can easily get to see if we want to—and that includes the museums and the galleries which are no more intimidating than walking into your local car dealers really—to me, all of this is public art. Some people make a big thing about the notion of public money being spent on art, but I don't really go for that idea much, as when compared to the cost of filling holes in the roads it's nothing, and I'm speaking as someone who's done both. The point of this being that just because someone can afford a car and has paid for it, doesn't mean we aren't paying for it as well; we are paying for it big time, in lives and maybe much more than that. As this new perspective on public art as anonymous, as just part of all the other stuff we live with for good or bad, was a new one to me, I added it to the usual list of descriptions for public art works: art as itself, as a commodity, as part of a collection, as a monument, as a memorial, as decoration, as a collection of art outside of the museum, as community based, or as site specific.

1 Leach, Bernard, *A Potters Book*, London: Faber & Faber, 1940. Yanagi, Soetsu, *The Unknown Craftsman: A Japanese Insight into Beauty*, Tokyo, London, New York: Kodansha International, 1972.

Rosanjin, porcelain tea cups, overglaze enamels. Reproduced courtesy of Kodansha International from *Uncommon Clay: The Life and Work of Rosanjin*

At this point I should explain that my pleasure in this idea of the anonymous is, no doubt, linked to my early art education, which was a curious mix of Western and Eastern aesthetic ideas. I was heavily influenced by the thought of the Japanese writer and aesthetic philosopher Soetsu Yanagi, firstly through Bernard Leach's *A Potters Book*, and then through Yanagi's book *The Unknown Craftsman*, and, as a result, have always felt myself torn between the Western notion of originality and personal expression and Yanagi's notion of anonymous devotion to simply making things well.[1] Yanagi called his aesthetic Mingei (an abbreviation of *minshu-teki-kogei*, which literally means "the people's craft"). This was a modern concept, coined around 1924 when Yanagi and two, now famous, potters Kawai and Hamada were on a field trip to find folk craft in Japan. (It is thanks to Yanagi and his supporters that so much of Japan's folk artefacts have been preserved). The key to the aesthetic principle of Mingei is that, like my German friend's Rolls Royce, we recognise the quality even if we don't actually know who made it. We recognise the name of the car in the same way as we might recognise seto ware. If we allow that most of the works of art in our urban environment are actually anonymous to most of the people who see them, then the issues change slightly, moving from the identity of the artist, to how they give pleasure to those who live with them in their daily lives, and, perhaps more significantly, to the process and ethos by which these works become part of the world around us, how they relate to the overall aesthetic quality of our environment. For let's get it straight, now that we have invented aesthetics it applies to everything, not just art.

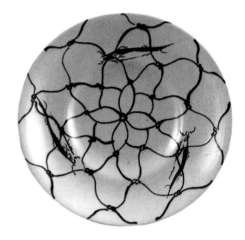

Rosanjin, porcelain dish, fish and net pattern, underglaze cobalt and overglaze enamel. Reproduced courtesy of Kodansha International *from Uncommon Clay: The Life and Work of Rosanjin*

Yanagi coined the term Mingei to contrast with the Western notion of the Fine Arts. This is a distinction we owe to the Renaissance when some artists separated from the guilds and established themselves as being distinct from artisans, as gentlemen rather than workers. Before then, however much the work of certain sculptors or painters might have been admired, they were no different from any other specialised trade. The notion of aesthetics, or the philosophy of art, is more recent still: the term was coined by Alexander Gottlieb Baumgarten in the eighteenth century, as a philosophical specialism devoted to

2 Kisteller, Paul Oskar: "The Modern System of the Arts": *Renaissance Thought and the Arts, collected essays*, Princeton: Princeton University Press, 1980.

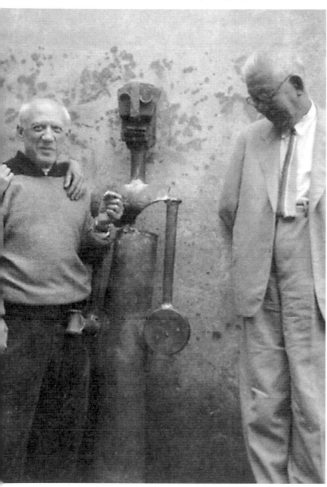

Rosanjin with Picasso in Vallauris, France, 1954. Reproduced courtesy of Kodansha International from *Uncommon Clay: The Life and Work of Rosanjin*

3 Licht, Fred, *Sculpture 19th & 20th Centuries*, London: George Rainbird, 1967, p. 16.

4 Graham, Dan, *Rock my Religion, writings and art projects 1965-1990*, Brian Wallis ed., Cambridge, MA: Massachusetts Institute of Technology, 1993, p. 70.

the understanding of beauty.[2] We have a tendency to think anachronistically and see all works of art, be they prehistoric, classical, or from other cultures, by values established by our very unusual and comparatively recent notions of what art and artists are, or what we think they should be. Art in the West, before and after the Renaissance, was dominated by the Church and by the monarchies of Europe. It was a kind of sacred propaganda, making the teachings of the Church visible to the uneducated and the illiterate, memorialising the great, be they saints, popes, bishops, kings, nobles, or their military conquests. Perhaps this is why we have a fear of public art, and expect it to have some sort of sacred or civic meaning, expect it to be telling us who we are and telling us what to do. There is a reason why I am attempting an historical *précis*; I am trying to implicate everybody, you, me—we are not separate from this, and it's not as old as we think it is.

It doesn't go all the way back in a linear way; it's complicated and it's new, and that's what is so damn good about it.

With the onset of the industrial revolution, the collapse of the power of the Church and the end of the divine right of kings, and of monarchy as a viable form of government with the American and French revolutions, the monument or the memorial, which had dominated sculptural practice and most forms of public art, began to lose credibility. Its history during the colonial period is complex, as governments strove to impose their aims using art, architecture and design as a means of imposing their will and ideology, in the same way as dictators and non-democratic regimes have used, and still use, monumental works of art to impose their internal identity, and oppress those they rule.

The First World War marked the beginning of a new way of thinking about monuments and memorials. Nothing makes this more evident than the invention of *The Tomb of the Unknown Soldier*. As the art historian Fred Licht has noted:

> The anonymous soldier who is regimented out of all individual initiative loses his heroic aureole and, since wars are no longer fought in the name of the King (God's temporal representative), the very cause for which the soldier falls is put in doubt.[3]

After the War, most cities, towns and villages in Britain and Europe erected monuments to the dead, some of which are outstanding public works. But they are usually unheroic, abstracting rather than celebrating loss.

The most outstanding example is perhaps Charles Sargeant Jagger's *Royal Artillery Memorial* at Hyde Park Corner, London, 1921-5. The Second World War had an even greater impact; Fascism and Socialist Realism rendered realism and monumentalist propaganda abhorrent. Interestingly, as Dan Graham has so cogently explained in *Rock my Religion*, these strategies were rapidly converted to the cause of capitalism by being absorbed into advertising techniques.[4]

After the Second World War, however much people wanted to hold on to what had gone before, it was over. Everything had to change, and it did, and has done. The need for monuments or memorials hasn't changed, but what they need to be has. Post War, part of our urban landscape became an open museum where the commitment of the artist to the

project seemed to become a substitute for the loss of authoritarian dictate. The public ridicule of Epstein and Moore are good examples of artists being blamed for the loss of the so-called 'divine authority' described by Fred Licht. Despite their individual quality, most of these public works generally sit as if they have no relationship to their surroundings. They are rarely what we might term, very loosely, site specific.

The site specific thing is actually very late 1960s, early 70s. And the reason, in my opinion, why it still has a strange if wildly distorted relevance is to do with strategies of dealing with a world that is too full. It started in America with a group of artists who tried to move out of the galleries into new spaces—artists like Robert Smithson, Nancy Holt, Dennis Openheim, Richard Serra, the list could go on. But why did they do this? The walls were already full of paintings, and, thanks to the Minimalists, the floors were full as well. In fact, after they had finished with it, the only place left to go seemed to be the mind itself; hence Conceptual Art. If site specificity is, as I suspect, a response to an overcrowded and now culturally complex world, it is also an idea with subtexts: site determined, site oriented, site conscious, site responsive, site related, site generated. It has, as a term and a methodology, absorbed previous concepts, such as the memorial, the community, the decorative and the art work in public. Interestingly, a lot of the artists who initiated the notion of the significance of the site to the artwork located there—its interrelatedness—were also influenced by oriental Zen thought. Serra worked in Japan, others such as Smithson acknowledged its influence; they didn't make any pretence of understanding the religious or philosophical implications of Eastern thought, beyond recognising how they could use it to imagine new directions for their own work.[5] These then, in short, are the main back stories behind where we are now.

How do we proceed? Well, for me at least, the answer is simple. For this I look to an artist who was once considered Japan's equivalent of Picasso. In fact they met once in Valouris, France, in 1954. Rosanjin, whose real name was Fusajiro Kitaoji, was born in 1883, the son of a Shinto priest. Twice adopted, he became a renowned calligrapher and engraver of seals, carver of shop signs, a painter, a potter and above all an epicure. Rosanjin (which translates literally as "foolish mountain man") died in 1959, an internationally acclaimed figure. His position was the opposite of Yanagi; Rosanjin was highly critical of Mingei, and the animosity would seem to have been mutual. The thing that for me is so interesting about his work is that he made ceramics simply to ensure the proper serving of the food he served at the then famous Hoshigaoka (Starhill Teahouse). As he wrote:

Rosanjin's shop in Ginza, with shop signs in English and Japanese.
Reproduced courtesy of Kodansha International from *Uncommon Clay: The Life and Work of Rosanjin*

> To make food taste better, put it in a better serving dish. Eat, if possible, in a room with a view. Even if these goals cannot be met, it is necessary to bear them in mind.[6]

This is advice as to how we might improve the pleasure we take in all things, and very good advice it is too. Food is something we experience in the present; pure sensation as well as a pure need. We can make it better.

5 Serra, Richard and Douglas Crimp, "Richard Serra's Urban Sculpture: An Interview, July 1980", *Richard Serra: Interviews etc. 1970-1980*, written and compiled in collaboration with Clara Weyergnf, Yonkers, NY: The Hudson River Museum, 1980.

6 Cardozo, Sidney B and Hirano Masaaki,, *Uncommon Clay, The Life and Pottery of Rosanjin*, Tokyo: Kodansha International, 1987, p. 125.

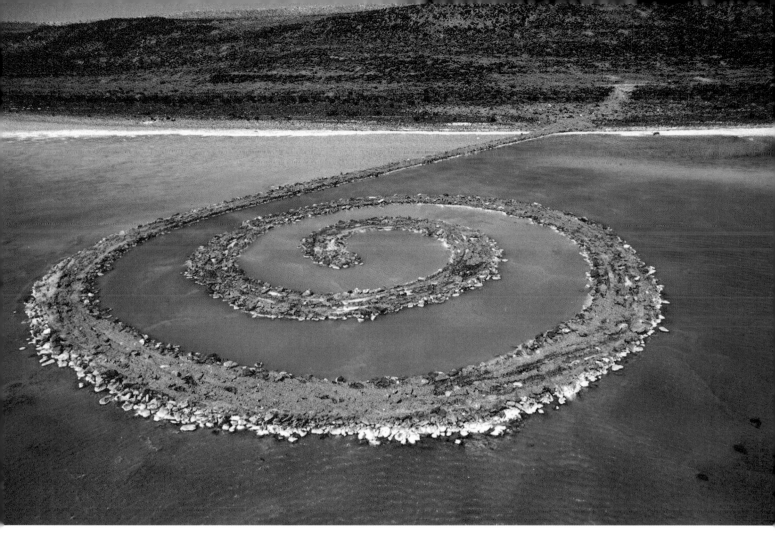

Robert Smithson, *Spiral Jetty*, 1970. © Estate of Robert Smithson

7 Roxy Music, *For Your Pleasure*, Island records, 1973.

The wonderful thing about art, architecture and design is that it is also there in the present tense; we can go back to it and change our minds, re-experience it, and everybody involved in producing the environment we live in can make it better, and we can all just enjoy it. You know, just being there, being part of the change, in real time, just like when the Rolls Royce rolled over the hill, beautiful, just being alive. A lot of people worked to make it happen, but, like it goes in the song, "For your pleasure in your present state"... and, as the song ends, with a female voice, siren like, saying rather than singing, "don't ask why".[7] And why? Well, as soon as you ask Why? you are out of the present tense and that beautiful 'just living it' feeling is over.

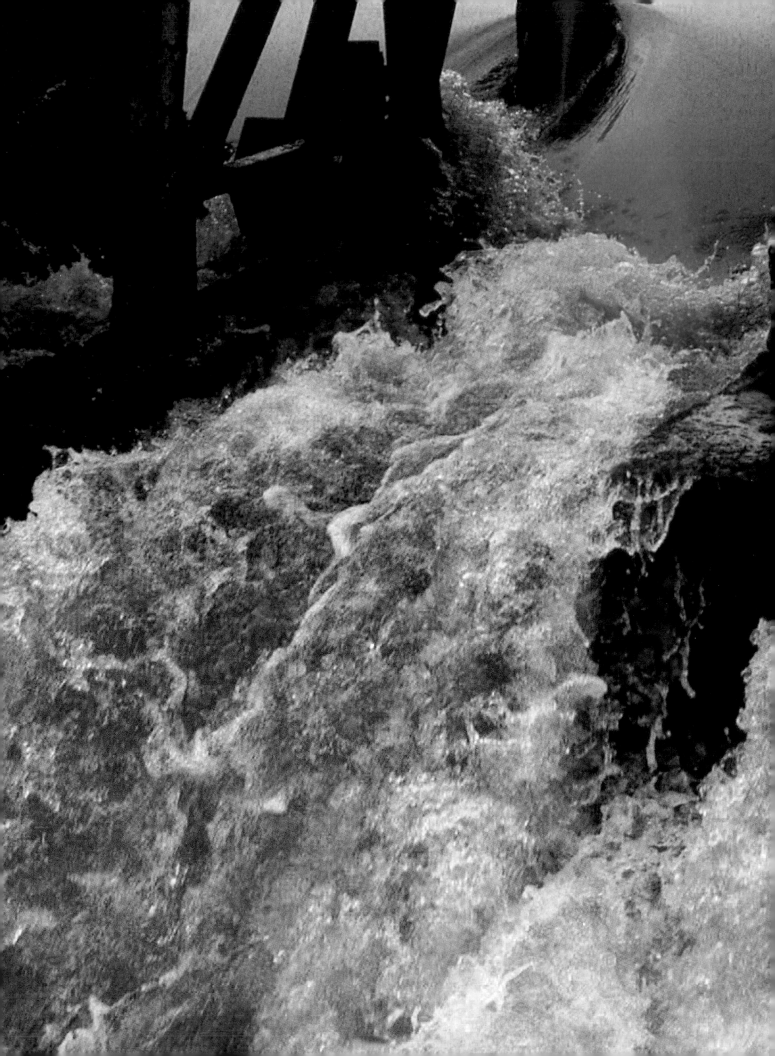

# Artists' Research
# Simon Read
# and The Thames
# Path Residency

"Projects do not readily fit into closed creative boxes. They are part of a wider journey that all participants make, where ideas intermittently surface, tumble, sink and then rise again." Stephen Turner

# Art and Citizenship
## Simon Read

I wonder whether most artists feel there is a time in their career when their experience across the cultural landscape outweighs that which could be comfortably absorbed into their studio practice. This could well coincide with a point when the expectation of rewards from a gallery career have become less pressing, and perhaps a kind of gallery fatigue has set in; there may be a realisation that it is after all only one system: it does not fit everything and sometimes, if only we can see it, there are alternatives.

Anyone who has tracked the art world long enough will be aware that its ups and downs are most likely a result of circumstances beyond our control; a shift in the economy or change in the political landscape can impact hugely and, because our investment is total, the effects can be overwhelming. Over the period 1979-80, I experienced an unexpected reversal in my fortunes: support for my work evaporated, I lost my studio in a warehouse fire, the gallery representing me in London closed down and my agent in Amsterdam baldly informed me that I was no longer fashionable. Although distressing at the time, this left me with the determination that, so far as possible, I would never place myself in that kind of position of dependence again.

Fast forward to 1993. The intervening years had been extremely active, but a struggle; I had a new life away from London and realised a link to a childhood obsession with all things nautical by living on a seagoing barge in estuarial Suffolk. I had been negotiating my relationship with this new landscape through an ambitious series of photographs of the land as seen from the sea, and immersed myself in an exploration of the methods developed by marine surveyors to draw reliable views of what you would expect to see, and where you would expect to see it upon making a landfall.

City Gallery Arts Trust (now Artpoint) approached me to ask if I was interested in an artist's residency on the Upper Thames. I was left in no doubt that my role would be to explore the river and, as one of my correspondents so aptly put it, "find out what made it tick". I was not expected to embark on a series of works, identifiably mine but transposed to another place, but given licence to do what I find irresistible—to explore a subject of which I may have a fundamental understanding, but still stands sufficiently aside from my experience to make what I am likely to come up with totally unpredictable.

My brief stipulated that I should walk the river and make contact with the working community, which included those responsible for its maintenance, from whom I was to derive a sense of the river as a dynamic entity, quite distinct from the way it was promoted as a leisure destination. I was immediately drawn to the question of a rigorously controlled water environment where the balance achieved between functions, such as drain, source of drinking water, viable natural habitat and quintessential English landscape, appears to be an heroic task.

The final outcome of the residency was a study of the control of water levels on the river and, more particularly, the loci of control: the weirs. Given the density of development in the Thames Valley, every effort is made here to address the likelihood of disastrous flooding, as far as state of the art engineering and sophisticated management systems are capable.

Previous
Simon Read, *Boulter's Weir* (detail), 1994, photograph

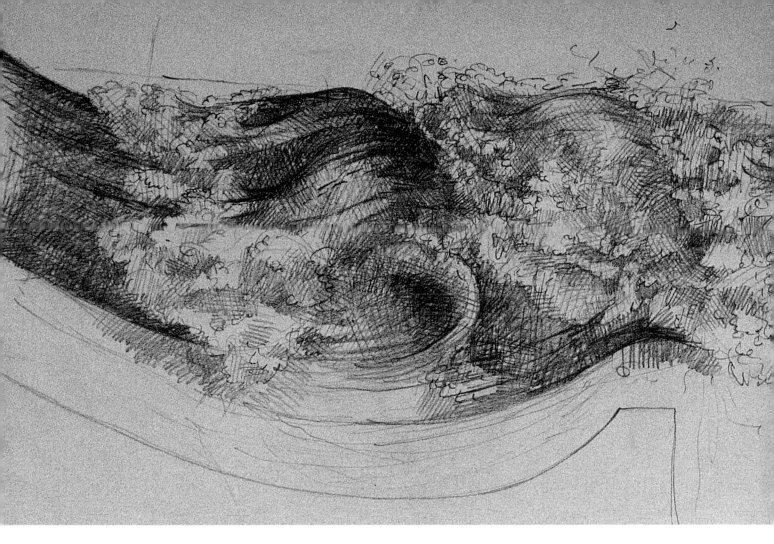

Simon Read, *Standing Wave 1,*
1994, pencil on paper

Since then I have aimed to incorporate my desire to directly enter debate through my position as artist, rather than encode it as artwork. This means that there is sometimes a tension between what is made and why, as well as a quandary over whether that which is embarked upon can ever become viable as work. However it has led me into continuing my enquiry into the behaviour of water in the form of a rambling conversation with the Environment Agency. There have been some positive outcomes, including commissions for the Thames Barrier (a profile of the River Thames engraved in the concrete of an 80 metre wall) and the new flood defence wall on Poole Quay (a series of 14 bas-relief granite carvings). This conversation has also equipped me with the confidence and enthusiasm to collaborate with a local community organisation in the consultation process with the Environment Agency over the development of a regional flood defence strategy. Here I am uncomfortably aware that the benefits for me are not likely to go far beyond an enhanced knowledge of hydrological matters. At present it seems unlikely that it will lead me back to art. Who knows? Through a natural course of events my identity as an artist has become synonymous with that of citizen. I see no harm in this; rather the very fact of survival seems to carry with it the assurance of continuity. New areas of speculation always arise from, and are informed by, that peculiar combination of insight and understanding we recognise as fundamental to art.

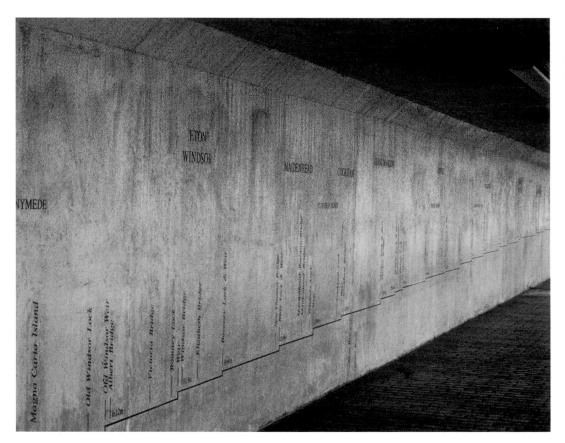

Simon Read, *A Profile of the River Thames from Thames Head to Sea Reach*, 1996, drawing and text sandblasted into concrete with enamel text, Thames Barrier, London

Simon Read, *A Profile of the River Thames from Thames Head to Sea Reach* (detail), 1996

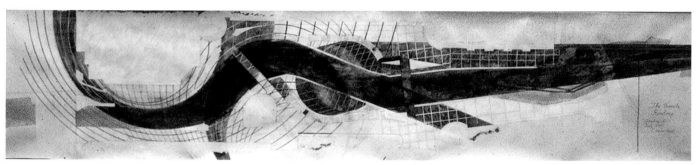

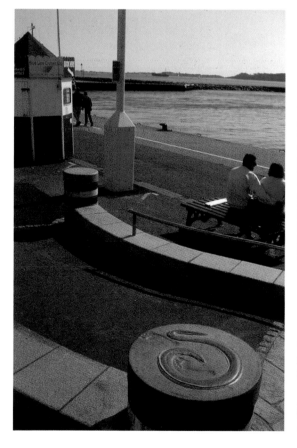

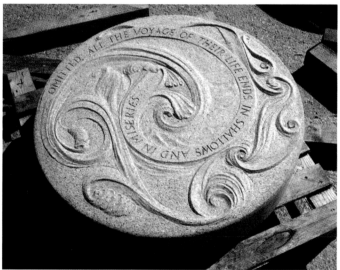

Top and Middle
Simon Read, designs for hard landscaping alongside River Kennet, Oracle
Shopping Centre, Reading, 1999. A commission managed by Free Form

Bottom
Simon Read, *Conger* (left) and *Shallows and Miseries* (right), from *Memory
and Tideline,* 2001, 14 carved granite bollards, Poole Quay

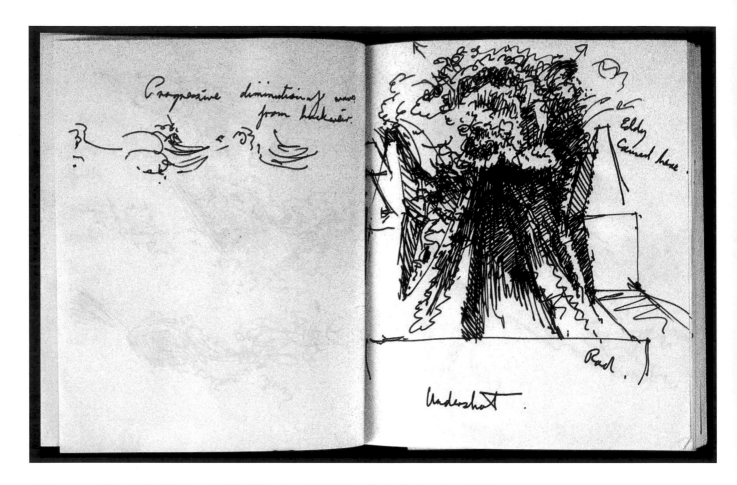

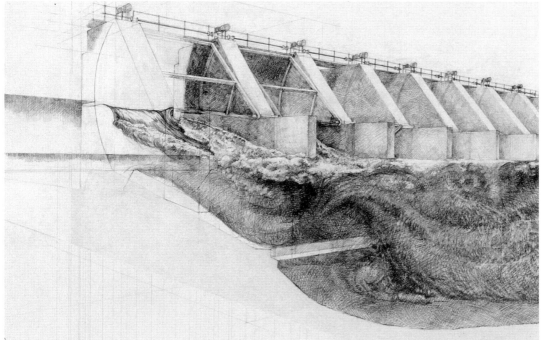

Simon Read, *Undershot, Romney Weir*, from the artist's Thames Path sketchbook, 1994, pencil on paper

Simon Read, *Romney Weir* (detail), 1994, pencil on paper

# Walking with Water:
# Simon Read's Thames Path Archive
## Stephen Turner

I have arrived at the River and Rowing Museum beside the river at Henley to meet with Michael Rowe, the Collections Manager, and to see the archive of the Thames Path Project, left in their care some ten years ago.

We come to a corridor whose floor is a work by Simon Read, in laser cut vinyl. It represents the widening Thames from source to sea, as a pulsing line of pale grey against ivory, flowing down the centre of the floor. It is on a scale of four paces to 334,400 paces and needs to be symbolically crossed to enter the inner sanctum of the library. Inside is a simple, unmarked cardboard box that is the Thames Path Archive.

I begin to sift through the many layers of photographs, journal notes, letters, contracts, cards and photocopies. These are carefully arranged in reverse chronological order, 15 centimetres deep and laid down like sediments in the river bed itself. The core of the material is Read's own report, signed and dated 25 August 1994.

The papers are rippled through with an enthusiasm to shape an art strategy for a brand new National Trail (the only one with water along its entire length) due to be opened two years later. I share the ambition, commitment, vision and risk of the artist and all the collaborators: City Gallery Arts Trust, now Artpoint; the Countryside Commission, now Countryside Agency; Southern Arts, now part of Arts Council England; the National Rivers Authority (NRA), now part of the Environment Agency; and sponsors Allied Lyons, now Allied Domecq.

We all change with time, and move onto other things, but what do we carry with us? What do we continue to say about the world and the way we live?

Simon Read's contract contains no education, training or mentoring role. A research residency like this was unusual, at that time, in the realm of public art. For Simon Read, it was a chance to march to his own tune for over 240 kilometres, criss-crossing the riverbank between Shifford and Teddington; a unique opportunity for "a conversation with the river" as he puts it, and "to find out what makes it tick".

The report reflects his curiosity on many levels. What is the river's shape and how has it come to be? How was it depicted before and how best to portray it now? Where do public and private interests meet? What is the importance of wild life and how is this balanced with opening the riverside to people? Is the Thames *La Source* or is it a sewer?

Read reacts with great honesty to his surroundings and to his encounters with others on his journey. Like Henry David Thoreau, whom he quotes, he shares a yearning for truth, for a life of principle and of social conscience, that colours all his research.

Walking in January 1994, from Henley to Reading, for example, he resents "from the start, the constraints imposed by this landscape of privilege and privacy, forcing me away from the river along an access road for fancy riverside homes". In February, walking between Goring and Wallingford he arrives at the Beetle and Wedge pub, where he finds the car park stuffed with Range Rovers, and "besuited people in the dining room, out to lunch, look out upon the river and bemusedly watch me, as I watch them as I plod by.

I was put off looking to eat there". My thoughts stray to the sponsors, Allied Domecq, whose principal reason for supporting the project included its wide range of waterside investments. Read's interest lay beyond the landscape of leisure and heritage.

"So the land that an aborigine walks or hunts on, is not just rocks and water holes. It is a sacred land, shaped by our ancestors and full of power and messages."[1] The phrase is highlighted in yellow on a photocopied page that surfaces briefly from the swell of archive papers.

1 Palma, Martin, "The Australian Aboriginal World", *A World of Difference*, World Wide Fund for Nature (WWF), 1989.

How poorly we live with nature. We reduce it to a series of picturesque views that distance experience and stop us looking at the real environment and the ecological impact we have upon it. I enjoy Read's feeling of relief when he realises that the river is capable of flooding, of asserting its natural force over our best attempts to control and tame it.

He is drawn to the 'keepers of the river', to the National Rivers Authority. Whether speaking with the surveyors, the Head of Recreation, the library staff, the river patrols or lock keepers, one senses an admiration and an affinity for this family of river workers who are driven by a passion for the Thames. He writes that framed pictures displayed in any NRA office are usually about the river, invariably reflect personal choice, and that the staff are ever ready to recommend a favourite image or book. This was a community to respect. Here were people who would share their knowledge about the river and enthusiasm for the animus of the water.

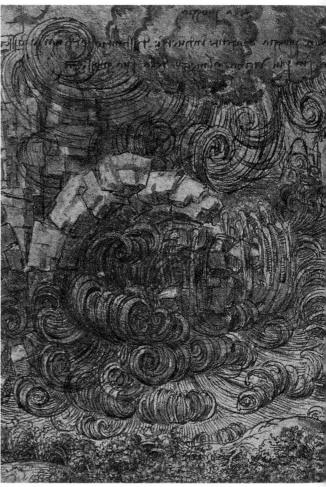

Read enjoys a conversation with the lock keeper at Romney Weir, who describes the water and weir as if it were his own child, called to be on its best behaviour for the visiting artist's camera and pencil.

The curator brings in a two metre wide scroll, and we unroll Read's large drawing of Boulter's Weir (with Romney Weir, one of two he completed). Linear perspective establishes distance, width and depth, framing the swirling water surface and the invisible turmoil that goes on beneath (in an imaginary sectional view). This is an involved investigation of the tension between static and dynamic, that reveals the river's flow without wholly explaining it; a poetic place where hydrological and artistic understanding meet.

Many sketches of flow patterns fill his journal pages and remind me of notebook studies by Leonardo da Vinci made over 500 years earlier, which also explore the mystery of the vortex and patterns of water-flow through a sluice. Both artists share an appreciation of something unpredictable, in a culture where, today, we think we have all the answers.

Water behaves chaotically, a change in one part of the system dramatically and unpredictably affecting another. Extrapolating from the empirical to a philosophical realm, it is possible to consider that the smallest human action can have an enormous and unknowable chain of consequences. I am suddenly glad for Read's determination to march to his own particular ethical tune.

In a letter to Artpoint, Read writes warmly about Victor Schauberger, 1885-1958, the Austrian 'water wizard', who regarded water as the blood of the earth and considered that we should let nature be our teacher; not a mere resource to contaminate, plunder and poison.

Leonardo da Vinci, *The Deluge* (detail), drawing, 1517-1518. Reproduced courtesy of The Royal Collection, © 2005, Her Majesty Queen Elizabeth II

Simon Read, *Boulter's Weir* (detail), 1994, 305 x 152cm drawing, pencil on paper

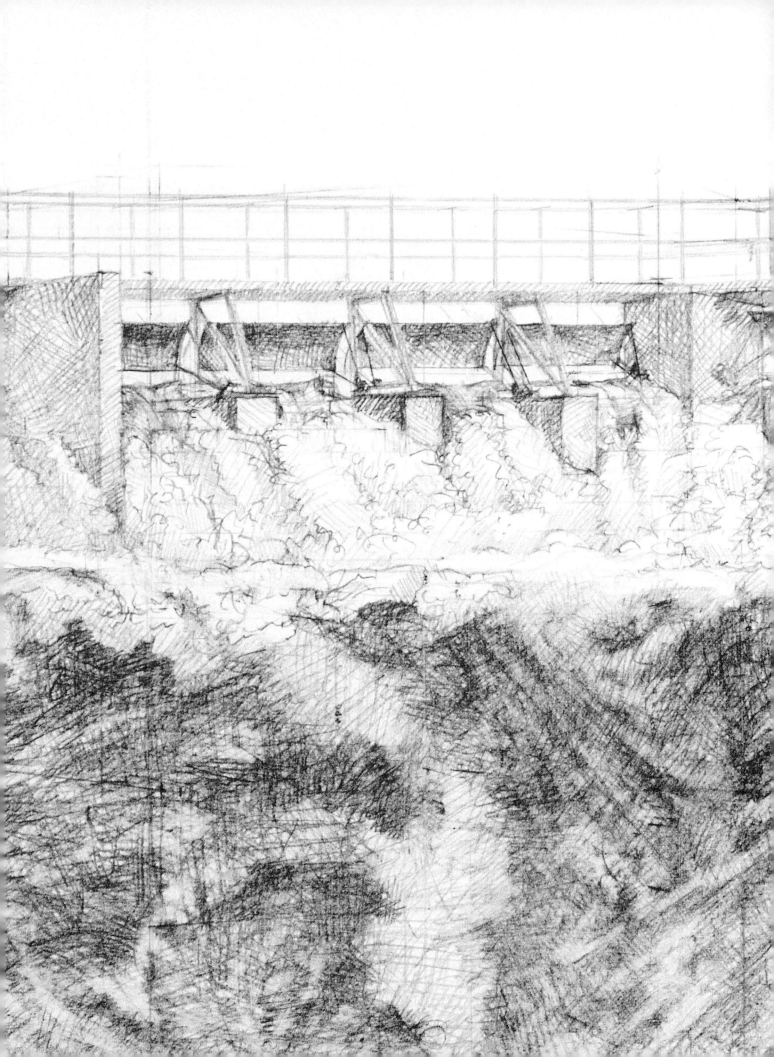

While there would be no bronze sculptures of Neptune astride a dolphin, nor benches upon which to sit and admire (prescribed) views, Read devises an idea to take his research to local people. A plan is outlined in a letter, for posters at the river's locks and weirs; community hubs, where the mill used to be, where the boats still slow or stop—places with message boards, where it would be easy to recast the artist's conversation with the river and its people. Temporary, potentially dissident (perhaps) and apparently costly, it was not the right time. The idea sits in my pile of papers like an oxbow lake on the artist's meander downstream.

Back in the mainstream of the archive, a photograph surfaces of Brindley's profile of the Thames commissioned by the City of London in 1770, taken by Read from an original in the archive of the late Tom Harrison Chaplin, hydraulic engineer and River Thames enthusiast.

In my mind's eye, I am at the Thames Barrier, looking at Read's commission to commemorate the launch of the Thames Path in 1996 (a more public work that followed the research residency). It is a polished concrete map on the floodwall, with an incised red line to show the fall of water longitudinally along the river. The 46 locks, the weirs and

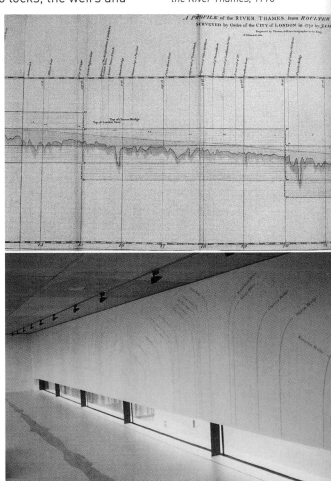

James Brindley, *A Profile of the River Thames*, 1770

bridges, the place names along its course are all letter cut in their appropriate places—50 paces to take in the whole 334,400 paces of the walk. The concrete is stained and looks like the old paper of Brindley's map. Half a metre up the wall, I recall a mark showing the flood level of 1993. This work would be flooded if the Barrier were closed to high springs on easterly winds. Is the positioning symbolic? Is there another undercurrent here about the need for humility in our relationship with nature?

Were there other outcomes? I find a note about the limited opportunity of time and funding to produce a publication to profile the project. However, this was a formative experience for everyone involved. Indeed, the sponsors were more used to working with the likes of the Royal Shakespeare Company. "I remember Simon" were Jan Buckingham's first words when I rang her at Allied Domecq. "The memory of doing something so innovative lasts a long time... people still say it was good to have done something so totally out of the box." Projects do not readily fit into closed creative boxes. They are part of a wider journey that all participants make, where ideas intermittently surface, tumble, sink and then rise again.

Andrew Graham, Read's principal NRA contact in 1993, still works on the river for the Environment Agency. "Simon's residency does not seem that long ago and I have still got a postcard on the office wall of a line drawing of a wave that he sent to me at the time." While bearing out Read's earlier observations, it is also an important measure of the subtle ways in which an artist's work is embedded. Perhaps this postcard is as important an outcome as the floodwall map.

I carefully arrange the papers I have read back into order, and for the moment the archive is closed. Leaving the Museum, I decide to walk along the riverbank that Simon would know so well. The river is dappled with light, reflecting the sky, and the water looks still as a lake. 300 metres on, the Thames Path crosses the river toward Shiplake on a timber frame bridge. It is closed without explanation and a walker engrossed in a map looks for an alternative route.

Simon Read, *Thames River Crossings*, 1998, inscribed wall drawing and text, inlaid lined marmoleum floor, the River and Rowing Museum, Henley

Simon Read, *Boveney Weir* (detail), 1994, photograph

Sacred Waters is at her moorings on the far bank. I take a photograph of her, resting my camera on a No Fishing sign. The sound of water roaring through the weir at Marsh Lock draws me up river in search of excitement. The walker looks frustrated, and sets off past me toward Henley town, placing a newspaper in the litterbin.

I pick out his *Henley Standard*, dated 10 January 2003, and begin to read about a flood on the Thames 18 months earlier.

Worst hit were Shiplake, Wargrave, Medmersham, Goring and Caversham. Hotels and businesses along the way reported heavy losses as the river reached its third highest levels ever. The River and Rowing Museum at Henley was completely cut off and forced to close. In Goring, lock keeper Mike Eagles and his family had to be rescued by boat after his house was completely surrounded by water.

What would Simon Read have made of this?

# Simon Read

*Falling water and a cloud of midges*, 2004, limited edition artist's print

Falling Water and a cloud of midges

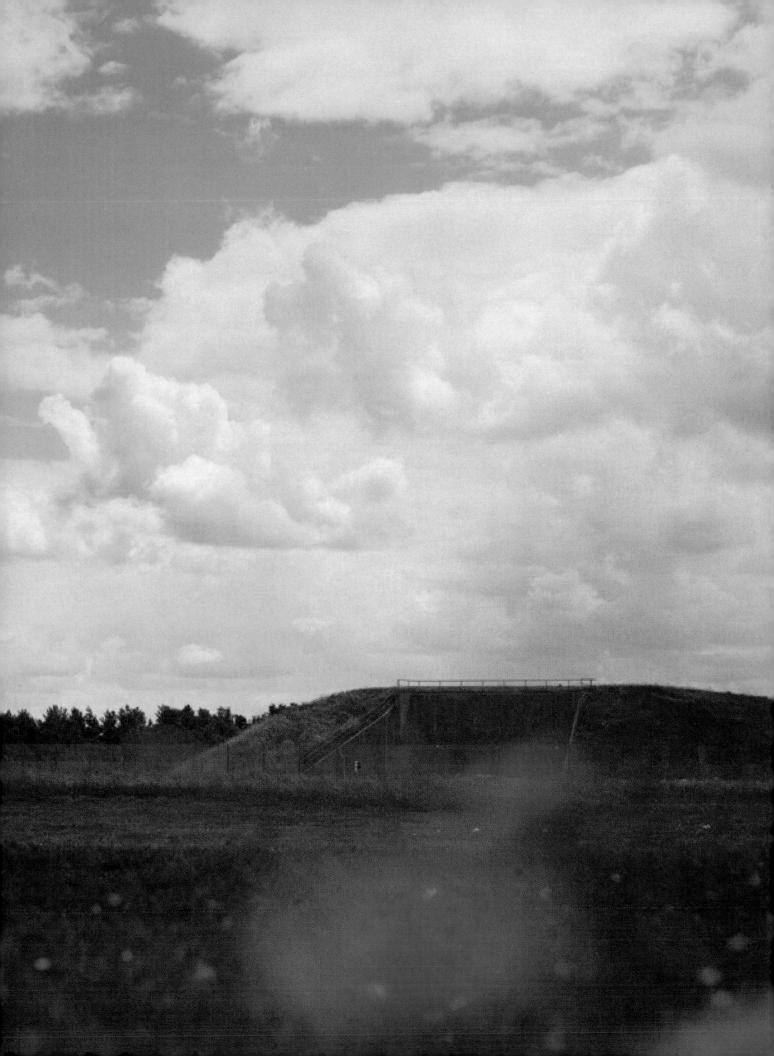

# Reflecting Histories John Kippin at Greenham Common

"Landscapes develop and decay, their encoded meanings concealed and frequently forgotten with the passage of time. The aim of my work is to open these closed systems, to place them within a tradition of representation which allows for a repositioning of ideas and ideology."

John Kippin

# Cold War Pastoral / SSSI
# (Site of Special Scientific Interest)
## John Kippin

In the introduction to the book *Cold War Pastoral* I wrote the following:

> When I came to Greenham in 1998 to photograph the Common, little remained of the United States airbase. The massive concrete runways were being broken up to make hardcore for new roads and the former barracks were in the process of being converted to a business and enterprise park. I wondered what I could possibly do that would make sense of such an undertaking.

> During my initial tour of the airbase, I became aware of a flat, gravelly landscape relieved by the occasional utilitarian structure that punctuated the mud and gorse. I remember my first sight of the sinister bomber control tower interior and thinking that, should the end come, it would be orchestrated from a formica clad chipboard console like this one. If not this actual one, maybe another one, set in another anonymous distant place. This meagre observation somehow set the tone for the project that was to follow.[1]

These words comment upon visual impressions of Greenham Common but there were other impressions that I carried with me. Although I felt excited by the possibilities in working on such a significant site, a part of me felt that this commission should have been offered to a woman artist instead of a man. I turned this over in my head, after reflecting on a number of issues relating to the womens' protest movement. Eventually, I considered Margaret Thatcher's part in the vilification of the Womens' Peace Camp at Greenham, and decided to press ahead.

All of the issues pertaining to Greenham seemed to be complex, and I researched as much as I could find on the history and geography and ecology, as well as issues relating to the local context of the Common, before making my own photographic images from the site itself. My initial impressions provided a useful working summary of my approach and the more I photographed the more I became aware of the particular narrative possibilities and direction of my work on this project.

Much of my previous work concentrated on the narrative within the structure of a single image, whilst allowing a freedom of association with other images shown broadly within the same context. As Mark Durden has observed:

> In *Cold War Pastoral* he (John Kippin) abandons the dialectic of the single image. The dialectical nature of this work is the result of cumulative relations set up between the pictures in series, the tensions and oppositions set up between the remains of the US military base and the richness of its pastoral landscape setting.[2]

The conflation of the military history of the American airbase with the experience of the pastoral environment was one that I found unsettling. It was perfectly possible to walk on the Common without seeing anything significant relating to its previous military function. This experience felt closer to visiting a war memorial than an experience of walking on

Previous
John Kippin, *Cold War Pastoral VIII*, 2001, C-type print

Right
John Kippin, *Cold War Pastoral XXXI*, 2001, C-type print

John Kippin, *Cold War Pastoral IX*, 2001, C-type print

1 Kippin, John, *Cold War Pastoral*, London: Black Dog Publishing, 2001, p. 4.

2 Durden, Mark, "Post Cold War Landscape: An Elegiac Documentary", *Cold War Pastoral*, London: Black Dog Publishing, 2001, p. 112.

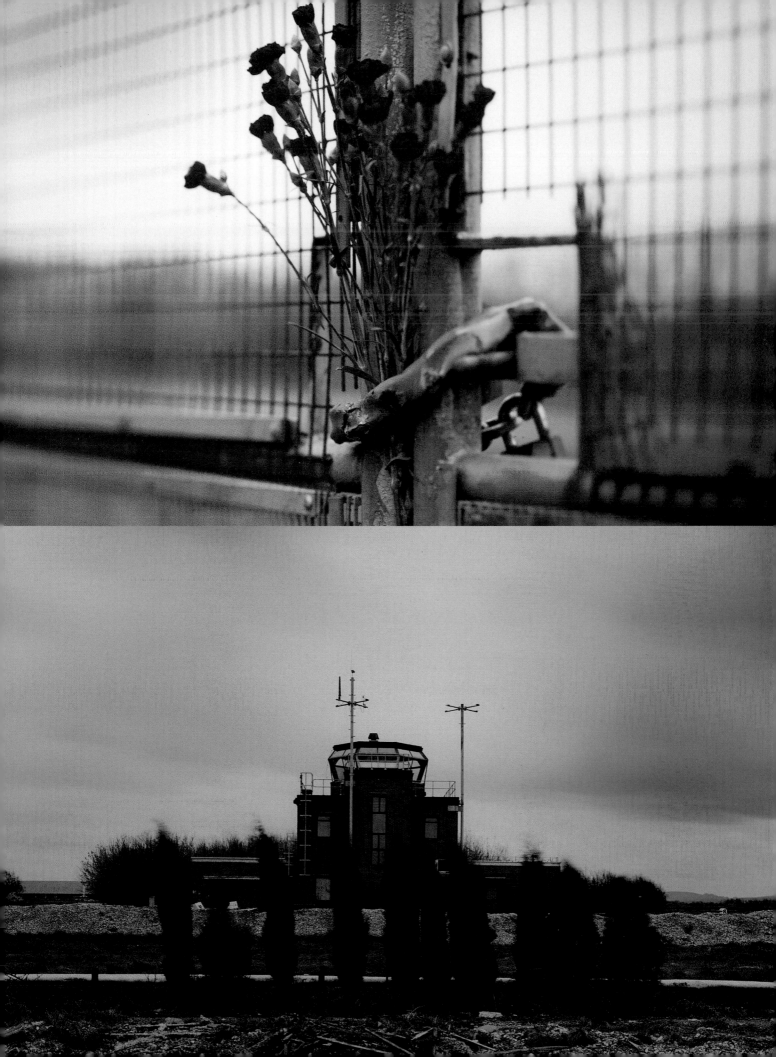

open countryside. Since working on the project I have re-visited Greenham and still experience the feeling that I am violating a place that has, in turn, itself been violated. Perhaps all of that negative energy can never be dissipated.

The process of working on the Common was, for me, a rewarding one. All of the people that I came into contact with were interested and helpful and wanted to engage with the project. I was fortunate in working with Ruth Charity from Artpoint, and together we discussed many options for the direction of the project. This creative dialogue meant that we were able to consider a number of initiatives appropriate to defining the outcomes of the work. We agreed that there would be two editioned posters, one to celebrate the re-opening of the Common to the public and one to publicise the initial exhibition. We agreed that there would also be a number of exhibitions, and possibly an interactive piece available on the Internet (although, due to various logistical problems, the Internet project was eventually abandoned). The Imperial War Museum (IWM) in London was an essential and valued partner in our thinking. The exhibition *SSSI Greenham Common* was first shown at IWM in London, before its installation on Greenham Common, in a specially

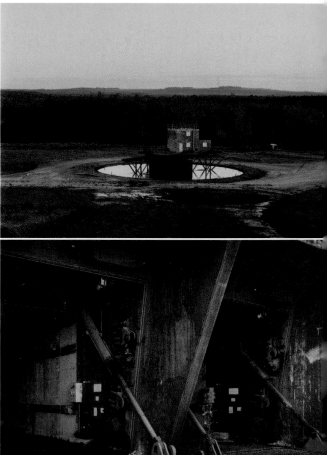

John Kippin, *Cold War Pastoral IV*, 2001, C-type print

converted workshop building. I also gave a number of talks and a workshop, all of which gave the project a local focus, balancing the other more nationally focused activities.

I had always seen the exhibition *SSSI Greenham Common* functioning in a different way to the subsequent publication, *Cold War Pastoral*. Since my work in the 1980s, I have been interested in the experiential qualities of photography as well as its indexical qualities. The experience of exhibition is a singular one and is one that I value. For the two exhibitions, I developed two bodies of work (with some overlaps), both with different narratives to suit the different contexts.

I have always felt uncomfortable about permanent artworks. As currently visualised, few survive the immediate context of their timing. Many are vandalised or destroyed. Some of this reaction is understandable. The journey from the gallery to the town square is an unlikely one. I have made a number of works within what is best described as public art and felt that the ephemeral nature of my work allowed me a freedom to confront a largely unspecific public audience for better or worse, much as product advertising permits corporations to exercise their rights in this area continually. I see ephemeral public artworks as assuming those rights within the same context, and as a reasonable activity, one that is appropriate within a progressive and liberal society.

My time at Greenham enabled me to take a particular journey and to use the time and opportunity to focus on issues and processes relevant to my work. It helped me to think about war museums, war artists and war photography and to consider within these contexts the narratives of landscape and its representation.

John Kippin, *Cold War Pastoral XXX*, 2001, C-type print

John Kippin, *Cold War Pastoral I*, 2001, C-type print

John Kippin, *Cold War Pastoral XVI*, 2001, C-type print

John Kippin, *Beauty Harmony*, one of a series of photographs taken of Compton Verney, Warwickshire, 2000, C-type print

John Kippin, *Hidden*, 1998, C-type print

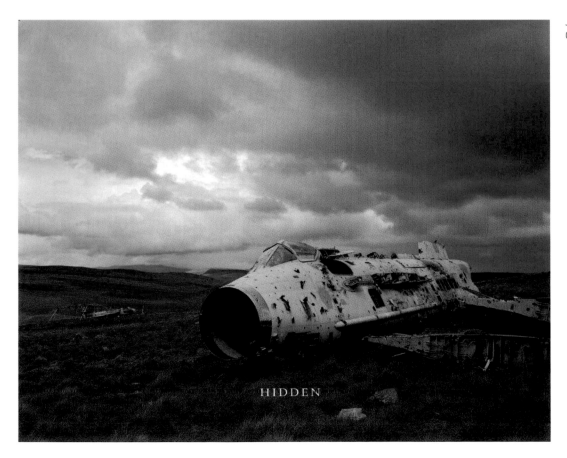

# A Visit to Greenham Common: John Kippin's *Cold War Pastoral*
## Ian Walker

It was, I remember, one of those September days when it already feels as if it is autumn. We left London in the mid afternoon, heading down the M4 towards Wales. It was about four o'clock when we got to Newbury and turned off onto the new A34 which sweeps south as if it were carving its way through Kansas. Then back on to the old A34, now the A339, which goes round the east of the town via a series of roundabouts.

This wasn't the first time I had been here. Back in the 80s, I was photographing Little Chef restaurants, then taking over the British roadside catering trade. I was initially amused by their Disneyish presence, until one day I read an article in *The Guardian* about how the Little Chef on the Newbury by-pass had banned the women from the nearby Greenham Common Peace Camp because they 'smelt'.[1] Trivial enough, but for me one of those moments when one realises that *everything* is political, and that in the Britain of the 80s, sides had been drawn up. So, when I came here a little later, I took the most unflattering photograph I could of the Little Chef next to the concrete swirl of the roundabout.

Now, the Little Chef was gone—indeed, it was hard to spot where it had stood. We headed on, following the signs to Greenham, and we found ourselves on the road that skirts the northern edge of Greenham Common itself. The day I'd photographed the Little Chef, I'd driven down here as well. Then it was a sort of war zone, a place of confrontation and threat, the fence surrounding the giant and mysterious airbase punctuated by camps at every entrance. Uncomfortably aware that I was both male and undemonstrative, I drove around and away.

Now, it was a very different landscape, more open, devoid of such drama yet hardly comfortable. The airbase had gone, the fence was lower, the Common once again accessible, yet it was still a sort of no man's land, too scarred to yet be the "Greenham pleasant land" promised us when the missiles had departed.[2] It remained a little unnerving driving along the perimeter of the Common with bourgeois Berkshire—large detached houses and a golf club—on one side, and this flat stretch of nondescript landscape on the other. (On the *Newbury A-Z*, the Common is still represented by a blank space.) The old control tower of the airfield came in view, one of the few recognisable signs of what had been here, and we were directed across to a corrugated metal building painted the same sandy yellow colour as the gravel that showed through the straggly cover of vegetation. It thus fitted and yet was quite alien. This was Building 150 and it was here that John Kippin's exhibition *SSSI Greenham Common* was installed.

The work had previously been shown in the Imperial War Museum, around the walls of a conventional white cube gallery. It was, however, a room with a view, out onto the extraordinary atrium of the Museum, filled with all the hardware of twentieth century conflict. As the babble of voices rises through the space, the building's previous history as Bedlam always seems most appropriate.[3] In contrast, the viewer must actively seek out the Museum galleries which, behind their glass doors, offer a space of quiet and contemplation. The very distance between the site of the pictures' making and the site of exhibition became part of their effect.

1 "21 peace women held in cafe ban protest", *The Guardian*, 4 January 1984. It was followed the next day by a picture of the women protesting outside the Little Chef, and later by letters and comments, including one that questioned why the women actually wanted to eat there.

2 This phrase comes from a postcard designed by Ken Sprague in the early 1980s, showing a flower growing out of a shattered cruise missile with the text: "And we shall build Jerusalem in England's Greenham pleasant land" (Leeds Postcard no. 115).

3 The Bethlehem Royal Hospital for the Insane, known colloquially as Bedlam, was founded in Moorgate in 1247, but between 1815 and 1930 it occupied the building that, in 1936, was converted into the Imperial War Museum.

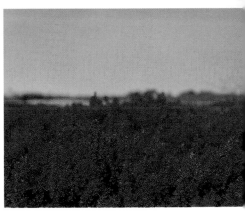

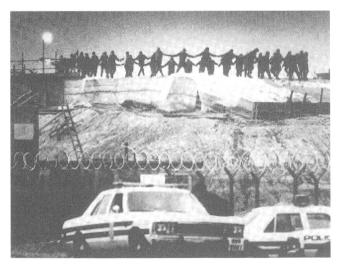

Installation of *SSSI Greenham Common* at Building 150, Greenham Common, 2001

John Kippin, *Cold War Pastoral XVII*, 2001, C-type prints

Raissa Page, *Women dance at dawn on a Cruise missile silo site in USAF Greenham Common*, 1 January 1983

In contrast, here in Building 150, it felt as if the photographs had come back home. It is always different, somehow more intimate, seeing pictures in the place of their making. To see an El Greco painting in Toledo is of another order than seeing it in London or New York. But, with photography, the effect is shifted and doubled, as the real landscape and the reality of the landscape *in* the photograph come into proximity. One can be measured against the other, revealing not only their closeness but also the distance between them. It is a siting that feels as if it should result in greater certainty, but in fact creates a heightened sense of the ambiguous relationship between reality and its representation.

This effect was accentuated by the hanging of the pictures. Whereas at the Museum, they had their backs against the wall, here they were hung on taut wires out in the open space of the building's interior. This was partly a result of the physical nature of the walls in the room, lined with a plethora of piping, wiring and other accessories. But it had a happy effect as the pictures floated in the space, freed from a strict adhesion to their surroundings. Yet they could not quite be detached. As one looked at a photograph, one might catch the red of a fire extinguisher in the corner of one's eye. At the same time, the function of this brutally functional space was gone. Now it was transformed, for a few weeks, into its opposite—a site of reflection and comment.

My attention was particularly drawn to a triptych at the far end of the space—three images of the Common, looking over a field of yellow gorse towards the control tower. In the centre picture, the tower was in focus and the gorse in the foreground was soft; on either side the focus was on the closest bank of gorse. The framing demonstrated an elegant solution to the problem of how to make the three images read as a coherent panorama, with the central photograph tight against the frame on either side. But the arrangement was not merely formal, offering also a subtle commentary on the shifting status of this landscape from military to natural, a process however in which its previous meaning cannot (indeed should not) be erased. The yellow flowers of the gorse also stand out, both physically against the dun, drab colours of this room and also against the historical representations of this place, which I remember as being predominantly black and white, urgent and grainy. Raissa Page's famous picture of the Greenham women dancing on a Cruise missile silo at dawn on 1 January 1983 almost looked as if it had been transmitted from the moon.

That photo was reprinted in the book that Kippin made of the work with the less descriptive, more resonant title *Cold War Pastoral*.[4] Studying this later proved an instructive example of the relative powers of exhibition and publication to produce what almost amounted to two different pieces of work. In the book, Kippin's images are bookended with text; indeed, he has described the block of his pictures as providing just one chapter in the volume. Before it come two essays by Sarah Hipperson and Ed Cooper on the history of the Common itself—accounts of its importance as a site of peaceful but persistent resistance and of its restoration as a public space. After the pictures come texts by two leading writers on photography, Mark Durden and Liz Wells, which analyse the place of these images both in Kippin's work and in a history of the representation of the British landscape.

In the midst of these words, the 37 photographs sit, reticent, implying rather than stating, murmuring rather than shouting. Where in Building 150, the pictures had worked with, and against, the physicality of the building and the landscape outside, here they worked with, and against, those words to build up an interleaved sense of this place and its larger historical meaning.

The relationship of History to Landscape has always been at the core of Kippin's work. What he wrote in 1994 of his images of a post industrial and heritagised Britain remains true of his photography at Greenham Common: "Landscapes develop and decay, their

4 Kippin, John, *Cold War Pastoral*, London: Black Dog Publishing, 2001. Raissa Page's picture is on p. 22. Kippin's triptych of the control tower is image no. XVII.

Paul Seawright, *Valley*, 2002
from the series *Hidden*

encoded meanings concealed and frequently forgotten with the passage of time. The aim
of my work is to open these closed systems, to place them within a tradition of
representation which allows for a repositioning of ideas and ideology."[5] His next
commission following *Cold War Pastoral* was to photograph the Robert Adam house and
Capability Brown gardens at Compton Verney in Warwickshire during the process of their
transformation into the setting for a contemporary art gallery. A very different site
resulting in different pictures, but the interest in the processes of historical change
remained.[6]

Sometimes, that change can be slow, almost imperceptible. Sometimes it is shocking
in its speed. Kippin started photographing at Greenham Common in 1998; already by the
time the pictures were exhibited and published in 2001, many things had gone. He was
working in a sliver of time during which the Common went from one thing to another, and
in some ways what he was picturing was what was no longer there. In this, Kippin's work
at Greenham Common can be placed in the context of what has become a familiar way for
contemporary photography to depict conflict—to show us its aftermath. David Campany
has called this "late photography".[7] A formative example was Sophie Ristelhueber's *Fait*,
images of the Kuwaiti landscape after the (first) Gulf War. It was seeing this work at the
Imperial War Museum in 1992 that first led me to think about this 'retrospective' war
photography and its siting in the gallery or museum rather than on the pages of a
newspaper.[8] More recently, there has been the very different work made by Simon Norfolk
and Paul Seawright in Afghanistan (the latter shown in the same room that Kippin had
exhibited *SSSI Greenham Common*).[9]

Perhaps where this tactic was first developed was in the work of photographers such
as Richard Misrach and Peter Goin depicting sites in the American West polluted by

5 Rogers, Brett, *Documentary
Dilemmas*, London: British Council,
1994, p. 28. Kippin's photographs of
this period were published in
*Nostalgia for the Future*, London:
Photographers' Gallery, 1995, with
a text by John Taylor.

6 See Kippin, John, *Compton
Verney*, Warwickshire: Compton
Verney House Trust, 2004. In
contrast to *Cold War Pastoral*,
there is no text accompanying the
pictures in this book.

7 Campany, David, "Safety in
Numbness: some remarks on
problems of 'late photography'" in
*Where is the Photograph?*, David
Green ed., Brighton: Photoforum,
2003, pp. 123-132. The main focus
of Campany's essay is on Joel
Meyerowitz's photographs of the
Ground Zero site in New York.

8 For the work in book form, see
Sophie Ristelhueber, *Fait*, Paris:
Hazan, 1992, also published as
*Aftermath*, London: Thames and
Hudson. My essay discussing the
siting of Ristelhueber's work in the
Imperial War Museum was
published as "Desert Stories or
Faith in Facts?" in *The
Photographic Image in Digital
Culture*, Martin Lister ed., London:
Routledge, 1995, pp. 236-252.

9 Norfolk, Simon, *Afghanistan*,
Stockport: Dewi Lewis, 2002.
Seawright, Paul, *Hidden*, London:
Imperial War Museum, 2003.

10 Goin, Peter, *Nuclear Landscapes*, Baltimore: Johns Hopkins Press, 1991. Misrach, Richard, *Bravo 20: The Bombing of the American West*, Baltimore: Johns Hopkins Press, 1990. *Violent Legacies*, New York: Aperture, 1992.

11 Calle, Sophie, *The Detachment*, Berlin: G+B Arts International/Arndt and Partner Gallery, 1996. This has texts in both German and English. A French version was published as *Souvenirs de Berlin-Est*, Arles: Actes Sud, 1999.

12 Fukuyama, Francis, *The End of History and the Last Man*, London: Penguin, 1992.

nuclear waste, an effect which is, after all, often quite invisible.[10] But, then, the Cold War—the era of nuclear proliferation and confrontation between the USA and the USSR—was the most invisible war of the twentieth century. Maybe it wasn't even a war in the strict sense of the word. Certainly, it left few memorials, and those there were, we have seemed anxious to get rid of. In Berlin in 1996, the French artist Sophie Calle went round what had been East Berlin and photographed the sites where Communist monuments had been torn down. Alongside her dumb, void pictures, she placed interviews with people on the street about what they remembered of the monument.[11] Her work is very different from that of Kippin—more conceptual, not rooted as his is in pictorial tradition—but it seems to me they have a similar belief in the importance of memory and an understanding that we must grab history before it slips away. But this can take various forms. Photography can sometimes capture a memory before it is gone, but it often gets there too late and—just as valuably—records the gap that has been left.

With the end of the Cold War, there was a triumphalist tone in the West. Democracy—more precisely, American Capitalism—had won. Indeed, some believed that the conflict was *finally* won; the American ideologue Francis Fukuyama, for example, proclaimed that this was "the end of history".[12] It was, in retrospect, an extraordinary act of hubris.

The date of our visit to Building 150 was Sunday, 2 September 2001. Nine days later, we were again driving along the M4 and turned on the radio to hear that two planes had just crashed into the World Trade Centre in New York. Beyond the windscreen, the rushing traffic seemed unreal and the world uncertain. History hadn't ended—it never does—but it was entering a new chapter and the war of Greenham Common slipped further into the past.

# John Kippin

*Mutual Consent*, 2004, limited edition artist's print

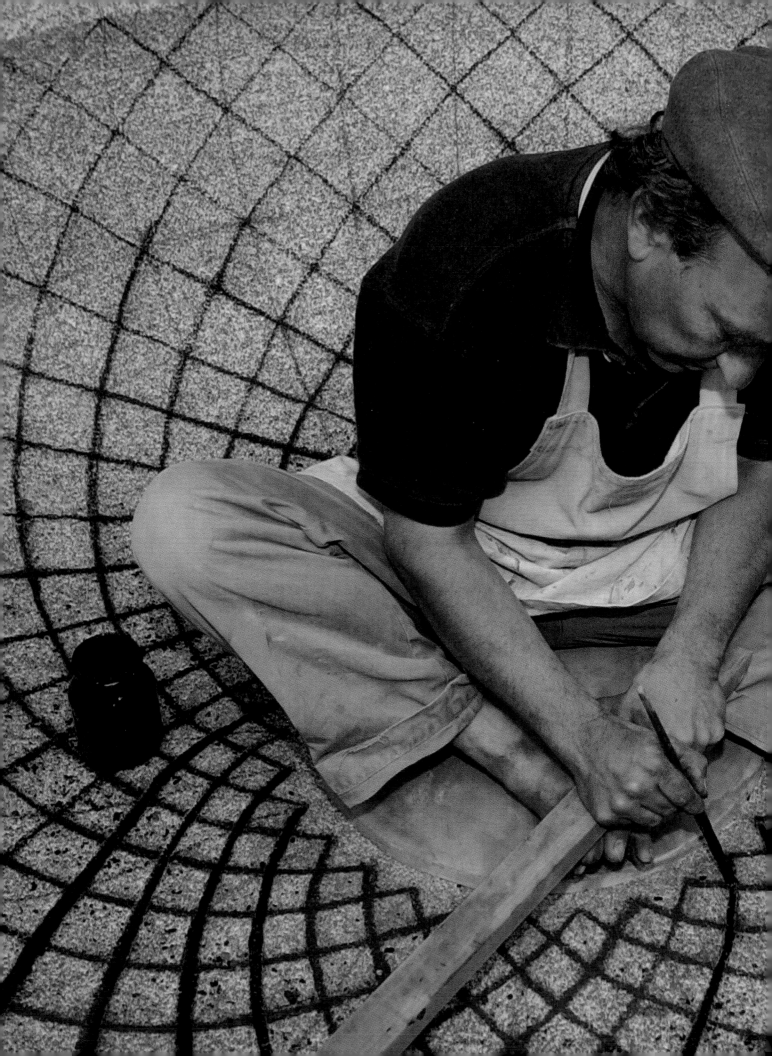

# Responding to the Landscape
## Peter Randall-Page at Newbury Lock

"My sculpture has always been inspired and informed by the study of organic form. Over a period of 25 years or so I have become increasingly interested in the underlying principles that determine growth and structure in the natural world. These principles are geometric and mathematical and are the theme from which nature creates an almost infinite variety of forms." Peter Randall-Page

# *Ebb and Flow*
## Peter Randall Page

My idea for a sculpture at Newbury Lock grew from the site itself and the brief that water should be involved in some way.

On my first visit I was struck by the dramatic difference in water level between the Kennet and Avon Canal and the River Kennet and by the robust lock structure connecting them. I liked the idea of using the changing water level in the lock to activate the sculpture by gravity, without the use of pumps.

The concept was to set a massive granite bowl between the canal and the river at precisely the right level so that high water in the lock would be a few centimetres below the level of the rim of the bowl. The sculpture, entitled *Ebb and Flow*, is set at the centre of a spiral path, which descends from the towpath towards the river. The slope of the path determines the height of the bowl, which is connected by an underground pipe entering the lock just above low water level; as the lock fills and empties, so does the bowl. The path and the area immediately around the sculpture are paved with granite setts, with extra long stones specially made to act as a retaining wall.

My sculpture has always been inspired and informed by the study of organic form. Over a period of 25 years or so I have become increasingly interested in the underlying principles that determine structure and growth in the natural world. These principles are geometric and mathematical and are the theme from which nature creates an almost infinite variety of forms.

In many ways *Ebb and Flow* reflects this interest in geometry as an underlying principle governing natural processes and morphology. The growth of plants and the way liquids flow can both be understood in terms of geometry and mathematics. I carved the interior of the bowl with a complex series of opposing spirals, creating a pattern of diamond shapes, which diminish in size towards the central inlet/outlet. The interior carving of the sculpture echoes the tendency for water to form spiral patterns, which is enhanced when the bowl fills and empties (with accompanying, unforeseen, but rather nice, gurgling sounds).

*Ebb and Flow* is the latest in a series of water-containing sculptures, which date back to the early 1990s. The first of these was *Font*, 1991, an upright bowl carved in the form of a continuous coil. During the same period I made *Moon Vessel*, 1992, again a water container but more botanical in its imagery. In 1996 I was commissioned to make *Body and Soul*, a large granite bowl with gently circulating water for a new square outside the Tron Kirk on the Royal Mile in Edinburgh. These works either contain still water or use a pump to create circulation. The only piece other than *Ebb and Flow* that uses gravity to activate the movement of water is *Waterstone*, 1992, a natural granite boulder from which water constantly flows. Working with water always presents practical problems particularly in a public context, but I can never resist the elemental combination of stone and water.

Previous
Peter Randall-Page carving
*Ebb and Flow*, 2003

Peter Randall-Page, early design for *Ebb and Flow*, 2000

Testing water connection after installation of *Ebb and Flow*, 2003

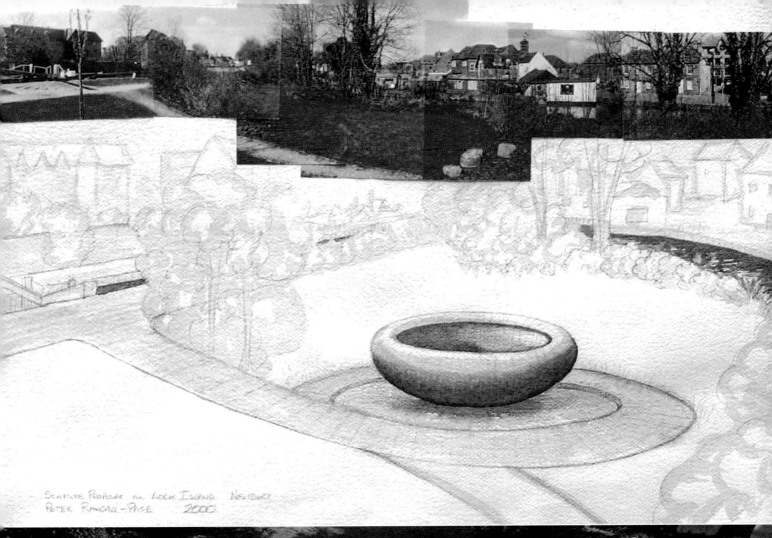

SCULPTURE PROPOSAL FOR LOCK ISLAND NEWBURY
PETER RANDALL-PAGE 2000

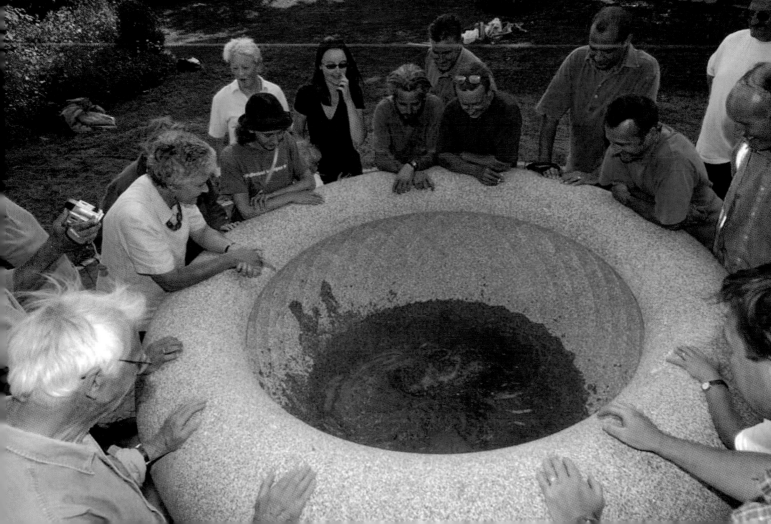

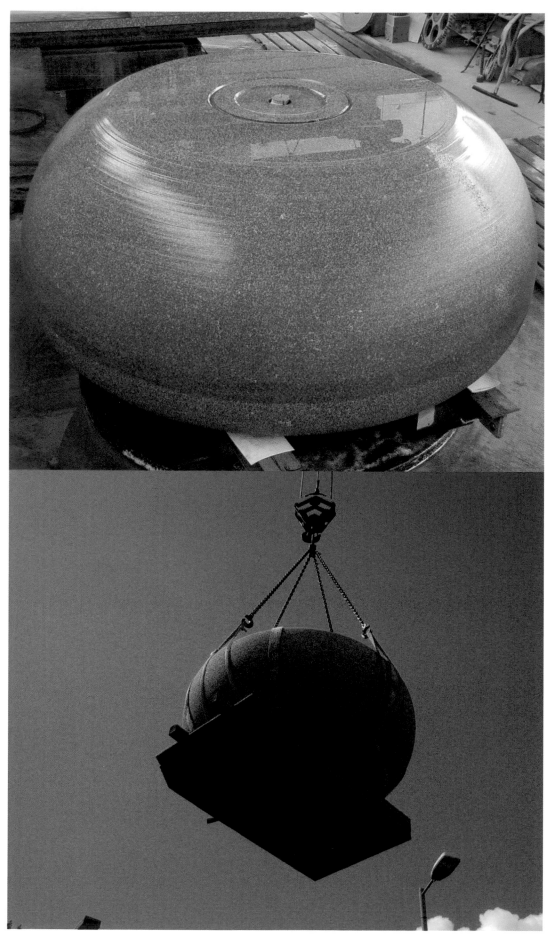

Above
Turning the granite bowl, 2003

Below
Lifting the sculpture

Above
Siting the sculpture

Below
Overview of sculpture

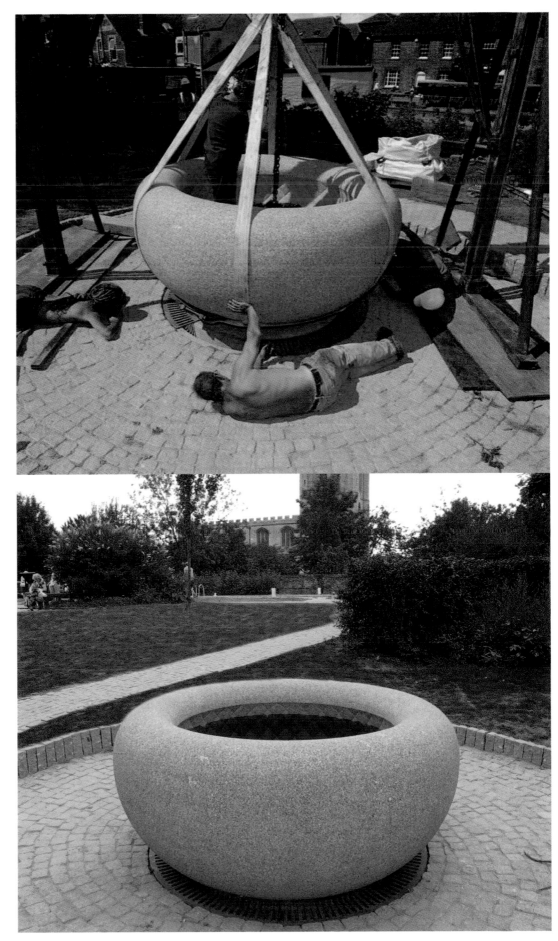

Peter Randall-Page, *Body and Soul*, 1996, granite and water, Hunter's Square, Edinburgh

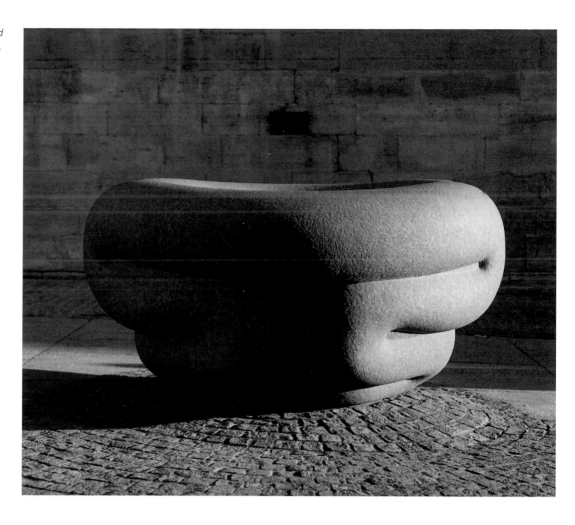

Peter Randall-Page, *Beside the Still Waters*, 1992, Kilkenny limestone, water and associated landscaping, Castle Park, Bristol

Peter Randall-Page, *Cone and Vessel*, 1988, Forest of Dean stone, Forest of Dean

Peter Randall-Page, *Wayside
Carving*, 1985, Purbeck marble
in Purbeck stone walling,
Dorset, reproduced courtesy of
Common Ground

Full Moon

# High Tide in Newbury
## Roger Deakin

Newbury does not, as yet, feature on any known tide table. But perhaps the people who publish such things should think again, because part of the town is now at least symbolically tidal. The waters are those of the Kennet and Avon Canal, and the lock sluices, not the moon, control the ebb and flow in Peter Randall-Page's new sculpture on Lock Island. However, the moon's ancient relationship with water cannot be far from your mind as you stand before the intricately carved granite bowl of *Ebb and Flow* and watch fresh water tides rise and fall in the middle of a land-locked market town.

Reflected in water, floating in it as it floats in the night sky, the moon was quite naturally identified by our ancestors with rivers, lakes and the sea. Since we ourselves are more than 70 per cent water and spend the first nine months of our lives immersed in an amniotic ocean, it is quite possible that we ourselves may be more or less tidal and feel the gravitation of the moon: even, sometimes, to the point of lunacy. The spirit-level basin of *Ebb and Flow* is surrounded by a halo of cobbles that leads into a spiral granite sett path that is at once whirlpool, sea shell, snail shell, uncurling fern and snake—the traditional guardian of springs.

The confident stone bowl itself, carved inside into a swirling vortex, evokes comparison with Peter Randall-Page's earlier works. It also relates to a far wider range of the artist's work in its air of poised expectancy: a vessel containing all the natural grace of an acorn-cup or an open flower, alive with the expectation of a fecund drenching. It is one with his seeds, fruit, cones, coils, pods and gastropods: all nature's apparatus of increase, whose symmetry and pent-up power to detonate regeneration began to find most assured expression in the artist's work around 1987 when he moved with Charlotte, Thomas and Florence to an old cob and thatch longhouse at Drewsteignton in Devon. But the two works which come closest to *Ebb and Flow* are the island sculpture on the River Teign in Devon, *Granite Song*, 1989, in which a natural granite boulder is split open to reveal its innards, inscribed in meandering mirror images on the polished twin facets, and, most particularly, *Waterstone*, made the same year and situated close by the same river as part of a commission by Common Ground.[1]

In *The Poetics of Space*, Gaston Bachelard quotes the French critic Jean Lescure, writing about the painter Charles Lapique: "An artist does not create the way he lives, he lives the way he creates."[2] Water and granite form the natural day-to-day environment in which Peter Randall-Page lives, works and dreams. A stream runs past his home on Dartmoor, so he is never without the sound of water, and his oak woods fringe the dramatic and beautiful River Teign. The walls of his imposing barn studio are of Devon cob and whitewashed stone. Rivers and streams dash about everywhere, carving their winding beds in the granite bedrock that stretches west all the way to Cornwall and the Scillies, formed 290 million years ago by an eruption of the volcanic magma in the earth's crust. Granite does not absorb water or riddle itself with underground caverns like limestone. It shrugs it off and sends it tumbling headlong off the steep hillsides that flank the moor: the Dartmoor rivers are among the fastest-flowing in England. In one remote part of the

1 Common Ground (www.commonground.org.uk) is an arts and environment organisation, linking nature with culture, championing the positive investment people can make in their own localities, and inspiring celebration as a starting point for action to improve the quality of everyday places.

2 Bachelard, Gaston, Introduction to *The Poetics of Space*, John R Stilgoe trans., Boston: Beacon Press, 1964, p. xxxiii.

Moor, an enormous elevated peat bog over 600 metres up beneath Great Kneeset, no less than seven salmon rivers, including the Dart itself, rise and begin their journeys to the sea. Water running over granite can't help being a kind of Aboriginal dreaming, an ever-active element in Peter Randall-Page's imagination.

Peter Randall Page, *Waterstone*, 1992, Dartmoor granite and water, Two Moors Way Footpath, Devon

The granite water dreaming arises in *Waterstone*, hidden away in the beech woods by the River Teign downstream of Chagford, in the sculptor's home country. *Waterstone* is not easy to find as you follow the banks of the river. It is set back a little distance from the main path, near where a small tributary stream crosses a lesser track. It stands in a boggy patch surrounded by lush ferns, shaded and curtained by down-swooping branches of beech. Peter Randall-Page followed the stream and made a dam to create a reservoir higher up the little valley, then ran a pipe underground from the resulting pool down to the stone. The natural Dartmoor granite obelisk, its core drilled and hollowed vertically, oozes water through a navel at the centre of its domed apex, to gently inundate its outer surface, roughened so that the stream-water will seep evenly all over it, lingering and gleaming as it meanders down. Over time, this nourishing surface has attracted all kinds of mosses and small ferns to take root in it. The sculpture has settled naturally into its place in its modest greenwood camouflage, and now belongs to it as much as the natural granite boulders, trees and plants that surround it as though no one had ever made it. After the original intervention of the placing of the stone and pipe, all the processes since have been entirely natural. The water and the granite are simply being themselves, subtly altering: settling in.

It is characteristic of Randall-Page to leave his works concealed in the landscape, or only partially revealed, set back from a path or contained in a niche in a stone wall for example, so as to retain an element of surprise, of enigma, and a certain drama. *Waterstone* is not signposted or labelled in any way: walkers on the river path talk excitedly about it as though they alone had discovered it. In this instance, as with *Ebb and Flow*, there is some of the concealed ingenuity of the conjuror in Randall-Page's harnessing of gravity to cause water to levitate without the artificial aid of a pump. The connecting pipe and the head of water in the dammed stream or the canal lock are the hidden sources of the exuberant springs in both sculptures. The fountains of Rome originally operated on just the same principle, with miles of subterranean pipes and distant heads of water maintained high above the city rooftops in the surrounding seven hills. Gravity also operated the fountains, grottoes and waterfalls in the fabulous gardens of such Tuscan villas as Pratolino, Mansi, and Marlia.

On Dartmoor, Peter Randall-Page found inspiration for *Ebb and Flow* in the old network of leats that carry water freewheeling about Dartmoor, as beautifully engineered and crafted in their way as the canal system and the Kennet and Avon. Leats are like little miniature canals built with just enough gradient to maintain a flow. You can follow them, often for miles, tracing silver almost-horizontal lines across the contours of Dartmoor. Some, like the Devonport Leat, even pass through tunnels and over aquaducts. It is a little engineering marvel and runs 53 kilometres from high up the West Dart River not far from its source on Dartmoor to Devonport. The agile stream, hardly more than 15 centimetres deep, and a jumpable one metre wide, dances along a speckled, gravelly bed.

Around the time he was commissioned for the Newbury Lock project, Peter Randall-Page had been thinking about the idea of a tidal maze he would make, perhaps in South Wales where the tide races in over a level beach. He would create his maze inland, he thought, and connect it to the sea at low water mark via a leat on a very shallow gradient: the tide would fill his maze as it rose.

This is how the notion evolved of a dynamic installation on Lock Island: of the synchronised swimming of twin bodies of water, rising as one tide into a bowl carved

inside into a maze of granite instead of sand, through which the last of the water would slowly percolate. The rising of the water in *Ebb and Flow* is a dramatic event, a kind of ritual. Imagine the first time it ever happened: the sense of delight. That it could be predicted scientifically is neither here nor there. It is like the thrill of the moment on the beach when the tide comes in and fills the moat of your sandcastle. And, like watching the sunrise, it is also reassuring at some deep level because it tells you all is well with the world: that the laws of hydraulics are in working order. There is a feeling, as you witness the rising water in the bowl, of "something almost being said", as Philip Larkin wrote in his description of trees coming into leaf in his poem *Trees*.[3] Language and water are intimately related: feelings are said to "well up" or "overflow", you may feel "out of your depth", or "immerse" yourself in a book. You may be "fluent", or you may "dry up". The bowl so strongly resembles a font that the humble canal water, once in it, might logically be considered in some gently pagan way purified, so all the more potent with new life.

In another of his poems, Larkin says that if he were "called in to construct a religion" he would "make use of water".[4] It is the most poetical of elements, allowing of no sudden, awkward movements: even a stone dropped in sinks gracefully. No element ranges in form so dramatically from ice to invisible vapour. Even in the midst of turbulent chaos, water conforms strictly to the laws of mathematics, as a poem holds to its metre or form. One of the great sea swimmers of our age, Sir James Lighthill, sometime Lucasian Professor of Mathematics at Cambridge, proved this when he correctly calculated how to harness the notorious tidal currents that tear around the Channel Island of Sark and circumnavigated the island on six separate occasions, swimming backstroke. The movement of water is innately rhythmical: it will always try to spin itself into a vortex or meander. It is often musical too, as in the percussive, rhythmical breaking and sucking of waves on the whispering stones of a shingle beach or the symphonic roar of a waterfall.

3 Larkin, Philip, "The Trees", *High Windows*, London: Marvell Press, 1967.

4 Larkin, Philip, "Water", *The Whitsun Weddings*, London: Marvell Press, 1954.

Peter Randall-Page, *Granite Song*, 1991, Dartmoor granite, Two Moors Way Footpath, Devon

Peter Randall-Page's work, rich in allusions and connections, is often described as poetical, partly because of its closeness to nature and the strong sense of place it can evoke, partly because of its great lyric beauty and high regard for formality. The formality finds expression in a deep interest in symmetry and mathematics running through the work, and *Ebb and Flow* is no exception. By rising and falling in sympathy with the lock, the bowl-water mimics and reflects the life of the canal. It is a water-dance, a duet. But it is also a mirror coming up to meet each one of us, a version of Thoreau's *Walden Pond*. "A lake", he wrote, "is the landscape's most beautiful and expressive feature. It is earth's eye; looking into which the beholder measures the depth of his own nature."[5]

5 Thoreau, Henry David, "Walden", *The Ponds*, New York: Houghton Mifflin, 1854, p. 177. Reproduced in *Viking Portable Thoreau*, New York: Viking, 1947, p. 435.

A great many detailed measurements and calculations went into the creation of *Ebb and Flow* and its positioning in relation to the one-and-a-half metre difference in water level between canal and river. The bowl had to be seated at precisely the critical level to fill in concert with the lock. The spiral granite cobbled path is itself a kind of pun in that it coils its way down to the stone basin like a spring. Water will always spiral if it can: it abhors a straight line. We are all familiar with the little whirlpool as the bathwater runs

out, but rainwater always spirals down inside the drainpipe: it never runs straight but takes the long way round, as a river does when it meanders. A slow-motion film of a river's course down the centuries would show it moving like a snake across the landscape. It is no accident that to the Australian Aboriginal people, the Rainbow Serpent is the principal deity, representing water, the source of all creation.

It took a gargantuan lathe, the biggest in Europe, to turn the bowl itself. It weighs eight tonnes and Peter Randall-Page sat inside it to carve the double-spiral grooved pattern of diagonals radiating from the navel at the centre and cutting through concentric circles to create a constellation of diamonds suggesting the swirling of water. As the bowl drains, the last of the water dawdles and scintillates in the stone maze, picking out the pattern in reflected light.

Peter Randall-Page, *Waterstone*, work in progress, Peter Randall-Page and his son testing the water flow, 1992

The radiating circles of granite setts were designed and drawn to break out into the great mollusc of the spiral path, at once a vortex, a sea shell, and, inevitably in Newbury and the Kennet basin, a celebration of the rare and famous snail peculiar to this place: Desmoulin's Whorl Snail, *Vertigo moulinsiana*. The tiny, swamp-loving gastropod quickly rose to national prominence in the spring of 1996, when it was adopted by the environmental lobby as its mascot, and, in a gesture of magnificently surreal metaphor, slowed down the streamlined progress of the proposed A34 by-pass round Newbury. The intention of the new road was, of course, to speed the traffic through Newbury beyond a snail's pace. In the event, after one of the greatest environmental dramas the nation has ever witnessed, English Nature compromised, a snail sanctuary was provided, and the road built across Bagnor Island, hitherto one of the favourite haunts of the most famous snail in the land.

It is no accident that in the poetry of the names traditionally given to narrowboats—Water Lily, Hyperion, Argo, Albion, Pike, Chubb, Gogmagog—the snail should also feature strongly: Escargot is afloat somewhere, and in no hurry to arrive anywhere. The snail is the perfect symbol for the contrasting pace of the leisurely traffic that passes *under* the new by-pass on the Kennet and Avon canal. *Ebb and Flow* belongs firmly in the low-tech, slow food world of nature. There can be few more intimate ways of exploring your native land than by narrowboat. The meditative state of mind induced by water and its balancing act in this new installation is expressed in the pun of the title poem in the recent collection by Seamus Heaney: *Spirit Level*. *Ebb and Flow* is already attracting its regular bands of gongoozlers, the water gypsies' word for the onlookers who gather at locks to watch the boats passing through.

Archimedes would have enjoyed gongoozling *Ebb and Flow*. Plutarch describes how the mathematician would attend the baths each day, drawing geometrical lines in the moisture on his skin as he sat in the steam. He was not the last to have found inspiration in water and leapt from his bath crying "Eureka", but he might have raised an eyebrow at a high tide in Newbury, and a snail holding up traffic.

# Peter Randall-Page

*Fingers and Thumbs*, 2004, limited edition artist's print

# Engaging Young People
## Louise Short at Riverside Walk

"The contemporary artist can act as navigator, interlocutor, facilitator and guide." Richard Layzell

# *Mothshadowmovie*
## Louise Short

Five years ago, I worked with three schools in Aylesbury—Meadowcroft Infants, Meadowcroft Middle and Quarrendon High School—with the aim of creating a sense of ownership of Riverside Walk, a park adjacent to the residential areas in which many of the pupils lived. This was the first time I had worked within a school context, but I saw it as a continuation of my art practice, which has continually involved working with people from all different walks of life. Within this project I wished for young people to feel able to contribute their own ideas, thoughts and interests to what was a neglected park area, which no-one used, apart from some of the kids themselves as they rode around on their motorbikes or kicked a ball over the waste ground.

My aim was also to test the conditions for spontaneity with children in a public art context. The culmination of the residency was *Mothshadowmovie*, a temporary night-time projected artwork made with large illuminated drawings, insects and snails, all collected by the young people. This work existed only for a particular moment in time—a temporary encounter in an outdoor space. Exhibitions in white cube gallery spaces are familiar environments to me as an artist. A residency of this kind seemed to me to provide a context to develop a different relationship to my practice whereby chance and spontaneity were the fuel for making and discussion.

I began by introducing the children to some examples of contemporary art and the environment. Artists such as Giulio Paolini, Francis Alÿs and Richard Long provided a starting point to talk about issues of the body, found objects and situations within the landscape. The children were then invited to go outside to the park, collecting objects and taking note of their sensory experiences throughout the day. Such forensic activity meant that insects, river water and plants were put into jam jars, closely examined and labelled. The children created 'mittens' and 'boots' by sellotaping their hands and feet and then walking in the park, collecting a lot of tiny elements—feathers, insect wings, seeds, etc.—on the sticky surfaces. This act emphasised the awareness of really looking at, and discovering, the 'lower' world beneath the children's feet.

Schools workshop, 2000,
Riverside Walk

> Sometimes making something leads to nothing.
> Sometimes doing nothing leads to something.
> Francis Alÿs

There were times when children debated contemporary art so lucidly I was left speechless. Their efforts to depict their surroundings showed an acute sensibility and

Francis Alÿs, *Paradox of Praxis*, 1994. Reproduced courtesy of the Lisson Gallery and the artist

Richard Long, *Untitled*, 1965-6, painted earthenware and plaster. Reproduced courtesy of Leeds Museums and Galleries

desire to express deeply felt concerns about their local park which was *their* place, not the place of their parents or teachers.

Over 100 local people—the pupils, their parents, neighbours and friends—saw *Mothshadowmovie* on a Saturday night in July 2000. A large canvas was stretched between two trees, and images of the workshops were placed on an overhead projector and projected onto the 'screen'. The 'movie' took place as moths, snails, daddy long legs, beetles and other insects collected by the pupils, were placed directly onto the projector, creating giant silhouettes and enacting small dramas as they chased each other across the canvas. The success of the event was felt by the number of local people who took part in this shared experience—of looking at an artwork made by their children or friends.

Only weeks before the showing of *Mothshadowmovie* in Aylesbury, I discovered an empty building on Bristol's Floating Harbour and worked to turn it into a space for artists. STATION, a former fireboat station, has operated now for five years as a research space for artists and their audiences.[1] Through a commissioning process, artists have been given time to explore aspects of socially engaged practices. Such a place can have long-term impact as a vehicle for exploration; this is perhaps in direct contrast to a short-term residency like *Mothshadowmovie*. The residency brought home to me that meaningful relationships should be made over a sustained period of time.

A programme of events at STATION—including a super 8 film festival, an outdoor glass kiln, a mycological research project and a 40 metre tunnel—has enabled people from all walks of life to engage in the process of making art and discussing the purpose of art. It has become part of the daily life of the boat dwellers and the residents of nearby 'flats', as well as a place for artists to do what they do.

Within my own practice I search out found colour slides from the 1960s. Car boot and jumble sales are the sites for my purposeful searching for images which depict everyday narratives made at the time I was a child. These images are sorted and arranged into particular groupings, which can be as tentative as the colour of a particular stocking (American Tan) or a particular flower in a garden at a particular time.

Perhaps *Mothshadowmovie* will itself become etched in the minds of the children, and the snail's and the moth's eye view will enter their memories like shadowy phantoms. *Mothshadowmovie* enabled me to understand how images and experiences are inextricably linked, that art can be more than a state of encounter.

1 See www.stationbristol.co.uk

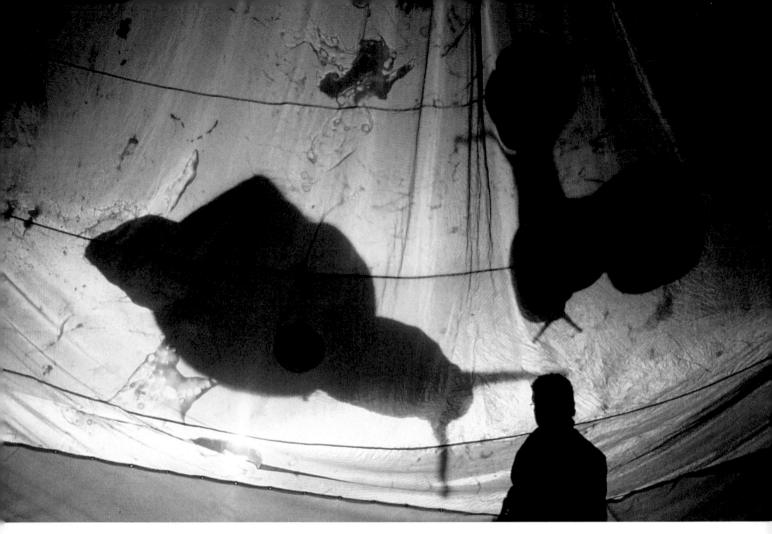

Louise Short,
*Mothshadowmovie*, 2000

Gathering moths and insects
and placing them on lightbox
for *Mothshadowmovie*

Exhibition of work from
Riverside Walk workshops,
2000

Images from Riverside Walk
schools workshops, and
exhibition, 2000

Louise Short, *Cockroach Cabaret*, 1996, bronze

Louise Short, *Collection of Hoof Casts*, and detail, 1992-7, plaster and cow dung, installed at Arnolfini Gallery, Bristol

Louise Short, *Ectoskeleton Projection*, 1998, at East International, Norwich

Louise Short, *Somewhere circa 1960*, found photograph

# Moths, Mosquitoes
# and the two Jennys
## Richard Layzell

1 Shave Farm was an international artists' workshop based in Somerset, encouraging open debate and discussion amongst artists. It ran from 1991 to 1997.

2 e.g. *Hoof Casts* 19927, *Cockroach Cabaret* 1996, *Ectoskeleton Projection*, 1998.

Louise Short's *Mothshadowmovie* has had several manifestations. But its unfolding at Aylesbury's Riverside Walk was "a cracker", as she says herself.

The integral process that led up to this event is both engaging and revealing. It began in 2000 when Louise was one of 20 international artists participating in a residency at Shave Farm.[1] Unlike most of the artists, who slept in the farmhouse, she chose to camp in a far-flung field, where her night-time experiments with light sources, white sheets and insects could unfold, while others slept, in similar white sheets, with the lights out. One evening a moth became lodged in the frame of her slide projector and created an enormous, startling, kinetic projection, an 'almost movie', by chance. And chance elements continued to be central to the development of *Mothshadowmovie*, which is also an event. By their nature, events are neither objects nor installations, nor are they static. They need witnesses, who can also be collaborators, participators and players. Louise is interested in spontaneous events, projects that "just happen", although this statement belies the breadth of her research and the wider context of her practice, which has consistently been focussed on significant enquiry into natural phenomena.[2]

Louise's early fieldwork led to an exploration of lepidoptery, including the Skinner moth trap, and the construction of a portable 14 by eight metre exterior projection screen, designed in collaboration with a parachute maker, and stretched between two trees. The projection itself gradually evolved into a visual symphonic improvisation of insects and snails, as they moved, scuttled, crawled and collided from jam jar container across the overhead projector screen and back into the night. No ordinary movie.

So how did this work engage with its audience in Aylesbury on 8 July 2000? What made it a cracker? The local schoolchildren taking part knew Riverside Walk intimately. It was their hangout. The British Trust for Conservation Volunteers (BTCV) became actively involved. As it developed, the project impacted on all the young people from the nearby housing estate. But the sum of these facts and details does not compile the answer. It was the quality and nature of the artistic concept that integrated and engaged the audience. Here the audience was also the community, an active ingredient, a central dimension, the locality. This work was about placement from the outset.

The contemporary artist can act as navigator, interlocutor, facilitator and guide. So 'audience' also needs an expanded terminology to complement the relationship. Where do we draw the line? In Louise's case, are the lepidopterists and parachute makers audience

Louise Short, *Mothshadowmovie*, opening credits

or collaborators? Was the boy from the housing estate who introduced the event as "Twentieth Century Moths" a performer, collaborator or member of the audience? When the generator kicked into action lighting up the screen and the kids cheered, were they acting as audience, performers, collaborators, witnesses to the event or members of the community?

These subtleties are not just about terminology. They are intrinsic to the expanded practice of the many artists who choose to work in the green field outside the gallery. This approach to art making is no longer an offshoot, but has become a major, almost mainstream, route to navigate.[3] Just as the audience may find themselves the subject and object of the work, friends and acquaintances of the artist, or the artist herself, may become the operator of the overhead projector, co-designer of the screen, lepidopterist, overall producer of the event and mentor to the local kids. These unfolding roles and divisions become intrinsically embedded in the work itself. We're in this together.

In my own case, as a resident artist in industry with AIT Plc between 1995 and 2002, even the category of artist ceased to make sense.[4] So I invented the label 'visionaire' which resonated more soundly to this community of 600 people, their visitors, the software industry in general and the wider locale. It also looked good on my business card. This re-framing was fine with me. I had a secret pact with myself and with the art world that I was an artist working exactly as I would be within any context. Some of my works were aimed at groups of eight, some at 600, some at the wider audience beyond AIT Plc, some were collaborative, some performative, some were essentially visual, others interventionist, some celebratory, others site specific, yet all of them clearly emanated from defined aspects of my art practice. This seven year project became a way of life. I was a member of this community as well as its borderline thinker and strategist. My 'audience' were in it for the long term. This was also their way of life, and their bread and butter.

And then there was Didcot, just down the road, where architects Ellis Williams were designing a new arts centre for South Oxfordshire District Council. The Council was looking for an artist to engage with local people in this design and consultation process, in a slightly different role from Jacqui Poncelet's. This became a lengthy process, one that outlived my connection with AIT Plc, but an equally interesting one. Here the circles of influence, contact and collaboration circulated between residents in new and existing groupings, the architects, and a number of key people, including Doris and the two Jennys. The initial concept to develop one intervention into the building process evolved into four discrete projects, each involving a different local group. We focused on windows, walls, door handles and the foyer space.

Audiences and communities are composed of unique individuals. Sometimes the creative process is about the quality and nature of the relationship between the artist and those individuals. And sometimes it's about recognition. Doris has lived in Didcot for most of her life. She was there when the colossal, landmark power station was under construction. As an amateur archaeologist she remorselessly trowelled and trammelled the chalky soil before the heavy machinery moved in. She unearthed countless mediaeval

3 As demonstrated by Jeremy Deller winning the Turner Prize in 2004.

4 An international software company based in Oxfordshire.

Design meeting at Ellis Williams Architects with Jenny and Richard from Style Acre, 2004

Jenny's jigsaw sculpture, 2002, film still

and Roman pottery shards, even mammoth's teeth, and has kept them wrapped in plastic, carefully catalogued, and stored in cardboard boxes in her garage ever since. In 2003 she came along to my evening workshop sessions at the Northbourne Centre, a converted church hall, and gradually the story unfolded. The following week she arrived carrying one of these cardboard boxes, filled with her finds. I was surprised and moved by the resonance of these delicate dusky fragments, partly for their link with local history, and partly for their connection with Doris. This became a defining moment in the thinking behind one of the proposals for the new building. Another came from meeting and working with the two Jennys.

5 Style Acre residential and day centre for adults with special needs in Brightwell-cum-Sotwell, Oxon.

Handles workshops at Style Acre, 2004, film still

Handles from Style Acre workshops at design team meeting, Ellis Williams Architects, 2004, film still

It was during the same series of workshops at the Northbourne Centre (of which, incidentally, Doris was the main key-holder) that someone mentioned Jenny Pozzoni and her impressive work at nearby Style Acre.[5] So we invited her along to the next meeting. She then suggested I visit Style Acre to see for myself, and here I found a ready-formed group to collaborate and consult with. Jenny avoids labelling her clients and prefers to see them as special rather than 'special needs'. Her relationship to them also defies categorisation. She has created a large central kitchen as a homely focus, with the neighbouring art room as a drop-in workshop of high energy and social contact. Tea and biscuits flow in and out of the adjoining door, while potatoes are peeled behind it. The surrounding gardens are extensive, informal and double as exterior workspace, probably not unlike Shave Farm, where *Mothshadowmovie* had germinated. Knowing that Jenny was also a professional ceramicist, it was evident that Style Acre was her innovation and a significant aspect of her creative work. Having arrived there directly from AIT that morning I was struck by similar concerns for community, for valuing the individual, for breaking rules, for sidestepping bureaucracy and hierarchy.

We agreed that I'd run a series of workshops with the Wednesday art group, exploring walls, floors, seating and door handles. There was talk of the other Jenny and how this would be her kind of thing. She was instantly recognisable by her barely contained excitement. I was keen to create some kind of bridge for this community to feel at home in the future arts centre. The vertical door handle was new territory for me, but I remembered discussions with Marcus Wiesen from the Royal National Institute of the Blind (RNIB) about the potential intricacy of the tactile grip and grasp of door and handrail furniture in public buildings. Surrounded by doors with nondescript alloy handles, we constructed extravagant alternatives and wrapped existing ones with fabric and foam. Working independently, Jenny produced an extraordinary palm-sized object from clay and jigsaw pieces. The intuitive leap in this proposal for the new building was the plan to produce a duplicate set of tactile handles for Style Acre itself, creating a sense of recognition and shared ownership. Like the other three proposals, it duly received funding for completion, but with specific time constraints. So, earlier this year, although a brick had not yet been laid on site, I was forced to complete three pairs of large bespoke theatre door handles.

I ran a second series of workshops, this time with Jenny Pozzoni's Monday Club, in a room behind the Didcot Leisure Centre. This regular evening gathering was very popular,

Richard Layzell, handles for Didcot Arts Centre, 2004

Richard Layzell, installation at the London School of Hygiene and Tropical Medicine, 2004

with about 30 people taking part, including the other Jenny. Their other activities included disco and karaoke, so the large PA system would occasionally be tested and tweaked in another corner of the room. I realised that this was now my core group of collaborators, consultants and audience. These handles were with them and for them. Jenny represented the group at a 'door handle design meeting' with the architect in London. She knew about ownership. And I gradually found myself rotating between key collaborators (The Monday Club), architect (Ellis Williams), art agency (Artpoint), project manager (David Clarke), client (South Oxfordshire District Council), handle manufacturer (John Planck Ltd), wood turners (Butlers of Willenhall) and my own design and concept ideas. This (at times surreal) navigation process became the work. The artist was out of the studio.

Over the same time span I was occupying the role of artist/visionaire at the London School of Hygiene and Tropical Medicine. The site for this commission was a former exterior corridor at basement level, linking the original 1920s building to a new glass and steel office complex. The audience were the walkers-through, several hundreds a day.

I chose to see this more as residency than commission, which, once again, changed all the relationships. What do you think? Are you interested in this original oak door from 1928? It could metaphorically lead the walker from old space to new space. Where did you find it? I sourced these grey metal louvre doors while you were away. Thought they'd give the kind of effect you're after (the construction manager became a key collaborator). What do you do? Research into malaria? Are there images of malarial mosquitoes in the archives, taken by the School's photographer? Have you thought about floor projections? The technology to throw an insect image from projector light to floor is quite straightforward and can be triggered by the walker.

And at this time I'd not heard about Louise's work. We're back with the entomologist and the audience, or the walker, the visitor, the participator, the community, the residents and the visionaire, or the artist, the maker, the designer, the facilitator. In *Mothshadowmovie* Louise literally projects or propels the almost invisible living flying insect towards star status. She opens the jam jar lid and the action happens, along with the intrinsic participation of us large faltering humans. We, she and they have no idea quite what will happen, but it's begun. By calling it a movie she cunningly, and intuitively, embraces Hollywood and popular culture.

These insights materialised while she camped, with the torchlight that could have been used for reading, a perhaps more sensible use of projected light, but not sensitive. These turning points in the creation of work so often come from the ability to recognise key moments or opportunities in the process or dialogue, or from simply enjoying the relationship.

# Louise Short

*Zebra Danio meets the Blue Bottle*, 2004, limited edition artist's print

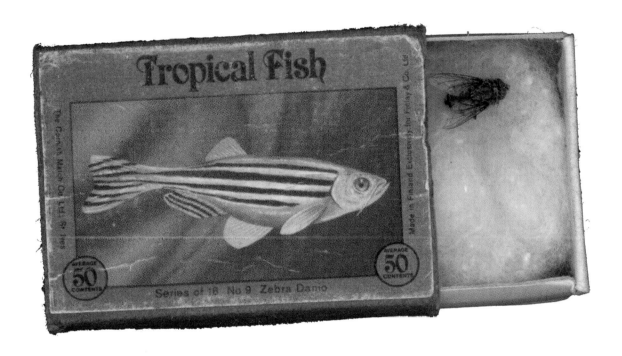

# Connecting with Audiences
## Peter Freeman in Winchester City Centre

"... the oldest, the noblest, the most straightforward and readily understood of purposes for public art: to provide a marker; to bring people together; to make people proud." John Gillett

# Luminous Motion
## Peter Freeman

For me, every project in the public domain offers the challenge of creating a fantastic light sculpture that responds to a specific brief, audience and location, whilst retaining my own voice and developing my own artistic concerns.

*Luminous Motion* evolved from a cocktail of ideas, about real and virtual pathways through Winchester, mixed up with my interests in the language of light, computer controlled lighting systems, mobile telephone text messaging and laser-cutting fabrication techniques.

The sculpture is a six metre mirror column of light, sited on one of the principal routes through the grounds of Winchester Cathedral. It incorporates the concept of a mediaeval Axis Mundi—the pivot at the centre of the universe, the symbolic thread that allows spiritual communication between heaven, earth and the underworld—with a modem and a computerised light control system that allows anyone with a mobile phone to communicate with the sculpture, making changes to the colour by sending a variety of text commands.

This was an important project for me because it brought together several strands of practice I'd been developing separately through other projects. I'd used fibre-optics and a simple mobile telephone system before, but never combined them together. In *Luminous Motion*, digital multiplex (DMX) controlled fibre-optics are used in a very integrated way. The light points express and articulate the surface of the structure. This, combined with an advanced mobile telephone monitoring system, gives the sculpture a complex interactivity. Programmed light sequences are triggered by a variety of text messages expressing abstract ideas about the nature of light through animated colour.

I also made a leap forward in the design and fabrication process. *Luminous Motion* was the first time that I used an all technical Computer Aided Design (CAD) process to realise a very precise and high-tech looking structure. It was a bit long winded as I drew everything in Illustrator (a computer programme) and then had to take the drawings to the laser cutters and have them all redrawn for laser cutting, but the results were just wonderful. I even discovered that the text I wanted to include on the base of the sculpture could be drawn and cut, which has been a big breakthrough. Through this I learnt to use AutoCAD and can now translate drawings directly into laser cut metal.

One of the most positive aspects of the project was working with committed clients who saw a real benefit for public art in the urban townscape and were really excited by my

Previous
Peter Freeman, *Luminous Motion* (detail), 2003, stainless steel and DMX controlled fibre optics, Winchester Cathedral grounds

Peter Freeman, design for *Luminous Motion*, 2003

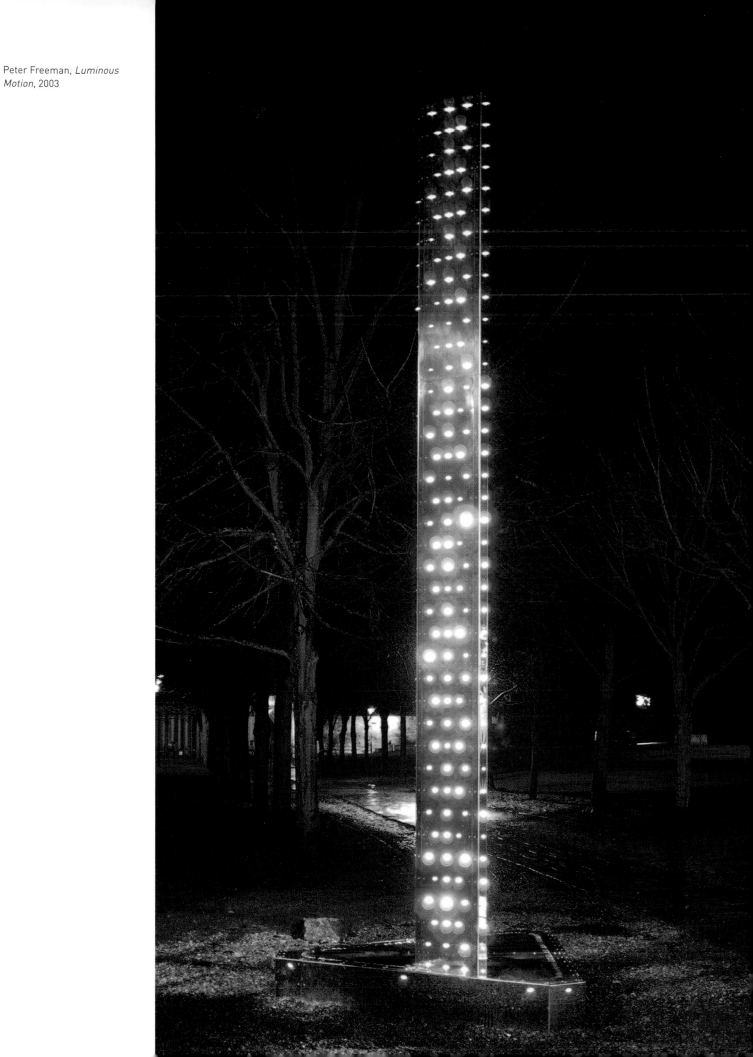

Peter Freeman, *Luminous
Motion*, 2003

Installation of *Luminous Motion*, 2003

proposals. I identified the perfect location for *Luminous Motion*—inside the grounds of the Cathedral and close to the retail centre—and they secured the permissions to make it happen. The result is a contemporary sculpture sited in a sensitive historical setting, looking comfortable, creating a positive ambience, and providing a new meeting place on a prominent pathway.

An interesting outcome to the project was the discovery that the sparkly, interactive lights broke down traditional prejudices about sculpture. By allowing people to make a direct link between themselves—through mobile telephone technology—and the sculpture, the barrier of high culture seemed to evaporate. It was great to find out that my main appreciative audience tended to be under the age of 20.

The response to *Luminous Motion* has been incredibly positive on all levels and has given me the confidence to dream up even more shiny, futuristic light sculptures. *Spectra-Txt*, *Pulse*, *Light Engine*, and *Travelling Light* are all subsequent ambitious light sculptures made possible through the realisation of this commission.

Peter Freeman, *Spectra-Txt*, 2004, stainless steel and text activated fibre optic light column, Middlesborough city centre

Peter Freeman, *Luminous Motion*, 2003

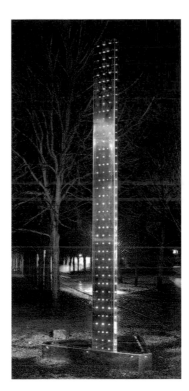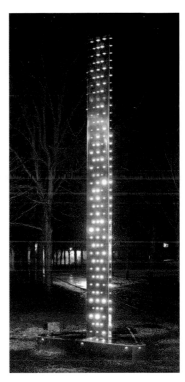

Peter Freeman, *Glamrock*, 2001, fibre optic and concrete pebbles that sparkle and change colour, Blackpool Promenade

Peter Freeman, *Deep Blue*, 2004, stainless steel and text-activated neon beacon lights, Oldham Art Gallery

Peter Freeman, *The Point*, 2002, fibre optic and stainless steel wedge for new housing development, Bristol

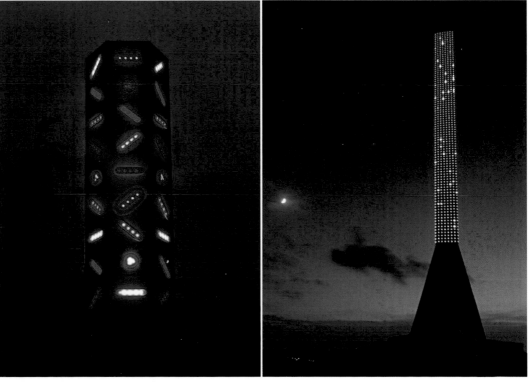

Peter Freeman, *Light Engine*, 2004, mirrored stainless steel and luxeon RGD lights, interactive sculpture for *Locomotion*: National Railway Museum, Shildon—texting early locomotive names triggers multi-coloured displays

Peter Freeman, *Travelling Light*, 2004, mirrored stainless steel and digital LEDs, a gateway sculpture to the West Country that changes colour with the seasons, Junction 21, M5, Weston

# The Light of the World
## John Gillett

This story is true. Except for the part about the hundreds of children appearing; I made that up. But at the time, when it didn't actually happen, there was the briefest of moments when I was quite convinced that it might.

It is a cold, damp Sunday night a couple of years ago I suppose, not so late in the day, but well past the kids' usual bedtime and wintry enough for the middle of Winchester to be pretty much deserted as we drive back into town after a visit to Nan and Grandad's. The kids have had a great day out and are very tired. They take some real persuasion to get out of the car when I park in the Broadway and tell them the day has one more little treat in store for them. In the previous week I have attended the launch of *Luminous Motion*, Peter Freeman's new piece of light art for the City Council, situated in the shadow of Winchester's ancient cathedral. As a member of some kind of steering committee, I have had but peripheral involvement in this work coming into being, but it is one of those things you immediately feel proud to be associated with the moment you see it: someone else's work that you want to show off to others, to be the one who brings it to their attention, and I am starting with my own family.

Mist is drifting in off the water meadows and softening the edges of the cathedral as we trudge along dark and empty back streets. The children are still reluctant and protesting: Why can't we drive home? Where are we going? Why must we wait and see? They are dragging their feet even as we turn one last corner. But, when they take in the sight I knew would greet them, they gasp in wonderment; they suddenly have wings, are carried off across the shadowy Cathedral grounds by an entirely fresh infusion of that special energy and excitement which always leaves the adults far behind.

*Luminous Motion* glints. It is a column of mysterious, glinting lights, and it glints out of the mist now with an entirely come-hither invitation, that the children are powerless to resist. As they accelerate away from us, crunching across the gravel towards the monolith, the little red lights embedded in the soles of their training shoes, so fashionable amongst their age group, flash out their rate of progress and simultaneously seem to take up the mysterious inner pulse of the light tower. As they are just feet from their objective, an immaculate coincidence occurs: I see another dad, also with two children, who are also wearing flashing trainers, appear from the townward side of the sculpture, their destination clearly the same as ours. All the kids, ours and the new arrivals, apparently known to each other, converge and mingle at the sculpture. The sound of their excited shouts and chatter is somehow absorbed by the dampness of the night, and the whole experience becomes predominantly visual. I see only the Light Emitting Diodes in their shoes, telegraphing their kinetic excitement, lights that seem to race along the ground towards the axis of the tower, there to be conducted skyward by its fluctuating rhythms. As we watch and continue our maturely paced stroll to join them, more children and yet more appear, out of the shadows, in their hundreds, out of the mist, out of the doors of nearby houses, climbing over walls or down from the trees, flashing trainers on every pair of hastening feet announcing their common purpose, dots of red light streaming towards

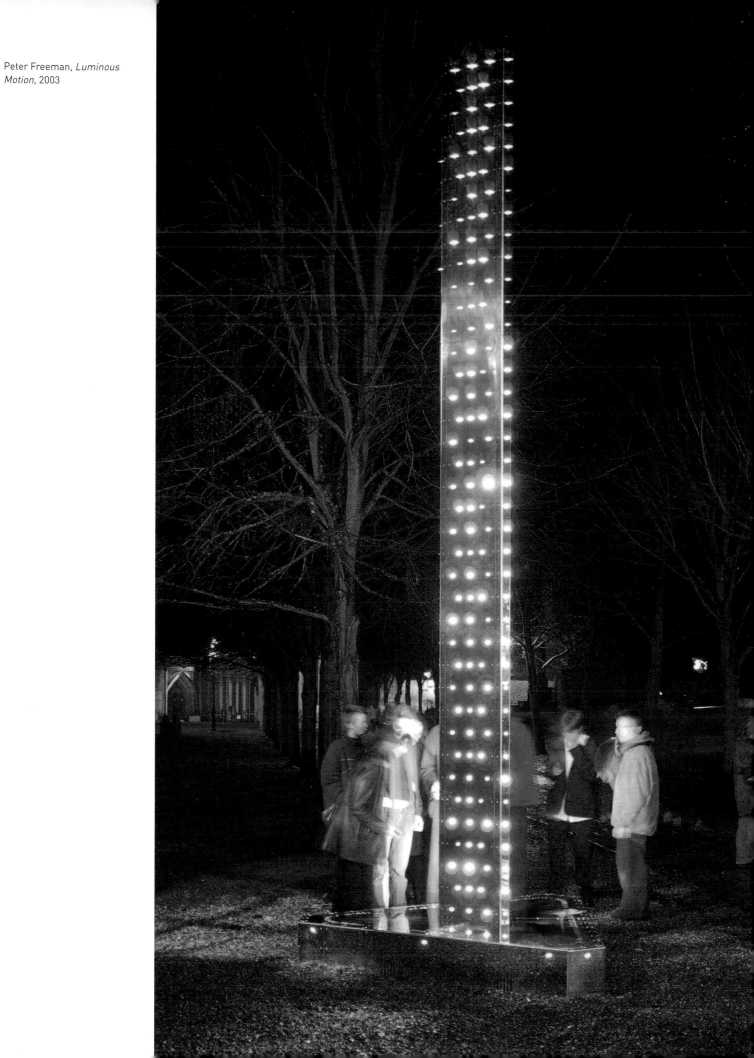

Peter Freeman, *Luminous Motion*, 2003

their goal. If Browning's Pied Piper has been employed in Winchester, we might be witnessing the settlement of his bill. As we arrive at last, a swirling dance of moving lights is in progress around the base of the tower, translated to the vertical in the piece itself, the colours softened, the energy slower but tending more to the perpetual. It is a magical, shared moment, in which fantasy is unleashed.

Time and again in the days and weeks that followed this incident, and frequently ever since, I have witnessed it re-enacted, fantasy-free, by young and old alike. In daytime as much as at night, *Luminous Motion* draws people together, intrigues them from afar, lures them in, has them share a common delight. People meet people they know there, whether by arrangement or by chance, the probability increased by the fact that the sculpture makes you dally to see its changes. The legend around its base offers a menu of moods for the piece, of colour and, I think, pace, and you are encouraged to make your selection by sending a text message from your mobile telephone. Even this process is of a sharing nature, on a group basis not normally associated with those wretched phones, as people first realise what is possible, then discuss who amongst them should make the call. Those of us who have resisted ownership of a texting device hang about and freeload colour changes brought on by the messages of others, then feel the need to confess; so strangers talk to strangers and an ancient crossroads in an ancient city once again fulfils its early function.

The Light Art project in Winchester had three phases, each with an artist's brief carefully designed to ensure that a different aspect of the city was addressed in each phase, a sub-plot which to a large extent was delivered by the project, but without anyone noticing or very much caring. On the other hand, what was very conspicuously achieved, but with minimal planning, was a boxing of the compass in terms of interpretations of both *public* art and *light* art. In Phase 1, Ron Haselden's *Colour Swatch* was public art that existed only *as* light, the pulsing light gently bathing the shop displays of an entire High Street in soft, new colours. It was ambitious, encompassing and inclusive, requiring the cooperation of a large army of installation volunteers and very many shop managers. It resulted in a subtle, hours-of-darkness piece which necessarily was short-lived. In Phase 2, Pierre Vivant's *alfreds.net* challenged still further standard notions of public art by celebrating the local and so-called ordinary citizens through the real-time presentation of CCTV views of their lives, on a website and on a High Street kiosk screen. Again, the technical challenges which the work had to overcome also meant that the piece had to be temporary, in accordance with the brief.

In such a context, Peter Freeman's piece for Phase 3 looks like a return to conformity: conformity with the notion of public art as statue, monument, obelisk; and with the idea that light art involves the conspicuous and extensive use of light bulbs or similar. And as we have seen, *Luminous Motion* surely serves the oldest, the noblest, the most straightforward and readily understood of purposes for public art: to provide a marker; to bring people together; to make people proud. But it manages to function in this simple way whilst retaining an enduring inner mystery. It is in the nature of its fibre optic lights, the eyes of a strangely wise creature, to suggest that there is an unfathomable inside to the object, deepened by its palpable connections to other places.

Again, *Luminous Motion* was by intention, and remains, a temporary piece, but it is now well into the second year of its six month existence. In this impromptu extension of service, as in its overall form and in the affection it seems to command, the piece to me resembles, on a much-reduced scale, the Eiffel Tower, which was constructed with a 20 year licence in 1889. Similarly, the London Eye opened in 2000 with planning permission for only a five year period, but this was made permanent by Lambeth Council after less

Ron Haselden, *Colour Swatch*, 1999-2000, radio programmed light sequence for 60 shops, Winchester High Street

Pierre Vivant, *alfreds.net* kiosk, 2001, stainless steel kiosk showing live webcam images, Winchester High Street

Pierre Vivant, Stills taken from video streams from *alfreds.net* webcams, 2001

than two years of operation. It is interesting that these obvious comparators for the way *Luminous Motion* has almost accidentally taken on the air of a lasting landmark for Winchester come not from elsewhere in the public art field, but from feats of engineering turned architecture. Both examples on their grander scales function in a similar way to the light tower as magnets for people, places for paths to cross. The elevated views they afford provide a *prima facie* functionality for both, in my comparison equating to the telephone interaction which is possible with *Luminous Motion*. But I think in each case, whether Tower, Eye or light sculpture, the visual characteristics of the object itself, engineered and easy to read, account for most of its enduring appeal. We could have included Lord Rogers's Millennium Dome in this list, but for the distracting debate and eventual commercial fiasco of its content. Meticulous planning, energetic discussion, and thorough research are essential to all public projects large and small, and the publication of which this text is a part documents professionalism of all kinds along these lines. But in the midst of such diligence, we have to be relaxed enough to seize an obvious opportunity,

The Eiffel Tower, The London Eye, The Millennium Dome. All © Ian Britton

in the way that Winchester seems to have done in the retention of *Luminous Motion*. The Dome got turned into a counter-example, in which overplanning and overcomplication missed the spontaneous appeal of a good idea. This happened simply because of a failure to recognise that the structure itself, described to this day with international superlatives, *was* the good idea.

Imagine having that space all to yourself for two minutes, under the world's largest unsupported single roofspan, devoid of all clutter; *that* would be worth the admission charge and the queuing time, wouldn't it? In my version of the Greenwich Millennium Experience, there would have been a spiral queue under a false floor all the way to a lift at the centre. The lift would have taken people one at a time up into the dome for two minutes of solitary awe and wonder. Another spiral queue would have led you out. In the queue, everyone on the way in passes everyone on the way out; people meet; people trade stories; phone numbers; start texting.

I know something of how this would work, because I have been in double spiral queues, again on outings with my kids. An annual tree dressing event at the Weald and Downland Museum in Sussex ends when the children have all hung decorated lanterns in the special tree and mediaeval marshals organise the crowd into a single hand-holding procession

Annual tree dressing event at the Weald and Downland Open Air Museum, Chichester, West Sussex

around it. Amazingly, after one revolution they somehow have the queue double back on itself, and before long the ancient twilight landscape is full of milling but orderly thousands, all passing each other in opposite directions. It always works, but it depends on holding hands no matter what. When hurdy gurdy music from the time of the Black Death finally stops, you make friends with the complete stranger who has just dislocated your shoulder. In the midst of the laughing crowd the soft colours of the thousands of lanterns in the tree gently pulse as the candles within flicker in the breeze.

Which brings us back to *Luminous Motion*, where Peter Freeman has tapped into this same ancient, communal ability to find pleasure in ritual around a focal point. The candles have been updated, via fibre-optics, for a new age in which proud parents at a school carol concert hold their portable telephones aloft to take pictures of the sweet performance, their features lit by the glow of LED screens and the play of infrared range-finder beams from cameras in the rows behind. Freeman has stated that *Luminous Motion* refers in part, thanks to its proximity to the cathedral, to the idea of Axis Mundi, the axis for the rotation of all creation and the communicating thread between heaven, earth and the underworld. The artist's website describes other pieces of work, publicly sited, in the same family. And so one realises there are ley-lines across the country linking light works you can text—and I've had conversations about *Luminous Motion* with people from Oldham and Middlesborough who've said, "Oh yes, we have one of those too". It brings an expanded sense of the sharing one experiences next to the sculpture; if mature adults wore flashing trainers, we would jump up and down together and our soles would glow in unison.

# Peter Freeman
*Construction* (detail), 2004, limited edition artist's print

# Sensibility to Place
## Sasha Ward at The Great Western Hospital

"Certainly the essence of a commission of this kind is holding a balance... between an artist 'merely' answering the perceived needs of the end users and the community in which the work has its being, and doing so in such a way that it is an integral part of their own practice— emotionally, aesthetically and philosophically." Hugh Adams

# The Visitor
## Sasha Ward

The sort of work I do now, such as my glass screen for the Chaplaincy Centre at The Great Western Hospital, is only partly shaped by me. I tend to work simultaneously on several commissions and each of these has characteristics that it gets not only from me and my response to the building in which it's sited, but also from the other people involved in the commission. These are people who are working on the building or who use it, and, in the case of the Chaplaincy, their views are just as important as mine.

When I look at the photographic record of my work, I'm also seeing the whole experience of being commissioned: the interview, the letter, meeting the people again, the architect, waiting for the measurements, the mistakes in the glass printing or the firing—remembering that feeling of being inspired and squashed at different times during the commissioning process.

How did I find myself in this position? I always wanted to make work for buildings and interested myself in art that was made for particular places. When I looked at examples, especially those from the world of architectural glass, there seemed to be two schools of thought. In the first, the art is in keeping with the building; it gets its power from its simplicity and its impeccable compatibility with its surroundings. In the other, the art is more like a visitor in the building.

As I began to understand that buildings were made for people, the second of these two schools began to have more appeal. When I started working on commissions for buildings, each with its own particular style and function, I began to realise how many aspects of the spaces where my work was to be sited I couldn't influence anyway.

Some of these spaces I imagine as meeting places for visitors, where the visitors are artworks and furnishings, each with its own style. Grouped together, they give the space a discordant or crowded feel, like a Roman Catholic church or an Edwardian museum. I find these sorts of spaces interesting, and the effect that they have on my own work when I design for them is to make it more intricate, more full of its own personality.

What I am trying to avoid in my work for public places is being bland. With this pitfall uppermost in my mind, I use a different approach for each piece. If the space I'm designing for is large and sweeping, I make the work simpler than something complicated and patterned that I've designed for a small space with a low ceiling. If subject matter for the commission has been stipulated in the brief, I try to use it, however bland it may be, in an interesting way. I have learnt how to use subject matter that is mostly rooted in the natural

Previous
Sasha Ward, glass screen (detail) for the Chaplaincy Centre, 2002, The Great Western Hospital, Swindon

Sasha Ward, glass screen for the Chaplaincy Centre, 2002

Sasha Ward, glass screen
(detail) for the Chaplaincy
Centre, 2002

world. This is the most specific change that I have noticed in the development of my work since I started working exclusively to commission.

Returning to look at the photographic record of my commissions, full of varied subject matter that has been given to me to use, I wonder whether it looks like a coherent body of work and whether my own individual style manages to win through. When people visit my studio, they often ask if I ever do any of my own work. I have always thought the question pointed to my dilemma about style over content, as if there were something else I should really want to be doing that had more meaning. The reassuring thought that they may just be asking if I have anything they could buy has just occurred to me.

I happened to be reading Phyllis Rose's memoir *The Year of Reading Proust* last week, and her answer to this same dilemma jumped out at me from the page. "The important thing was finding a way to put in words one's vision and sensibility; subject was of no importance whatever."[1] This is a reassuring thought for an artist who works to commission, but it also sounds too extreme for me. Her reassurance, however, had come from reading the last volume of Proust's *Remembrance of Things Past*:

> Style is for the writer, as for the painter, a question not of technique but of vision. It is the revelation, impossible by direct and conscious means, of the qualitative differences in the way the world appears to us, differences which, but for art, would remain the eternal secret of each of us. Only by art can we get outside ourselves, know what another sees of his universe which is not the same as ours and the different views of which would otherwise have remained as unknown to us as those there may be on the moon.[2]

1 Rose, Phyllis, *The Year of Reading Proust*, London: Vintage, 1998, p. 239.

2 Proust, Marcel, *Remembrance of Things Past*, Volume 2 of part IV, *The Past Recaptured*, FA Blossom trans., New York: Random House, 1932, p. 1013.

Sasha Ward completing the
installation of the Chaplaincy
screen, 2002. Reproduced
courtesy of the Swindon
Evening Advertiser

Sasha Ward, internally illuminated glass screen for three storey staircase, 2000, 82m² glass, Martial Rose Library, King Alfred's College, Winchester

Sasha Ward, roof light, 2004, Manor Green Special School, Crawley

Sasha Ward, glass screen, 1998, Rotherham General Hospital

Sasha Ward, three storey glass screen, 2003, Mid Devon District Council Offices, Tiverton

# 30 Years On...
## Hugh Adams

It has to be asked whether there is any intrinsic difference between artists' work on a hospital commission and one in any of the large variety of contexts now available to them? As one who has been advocating "art in public places" and thinking about associated practice for almost 30 years, the answer for me is a resounding "Yes!" And Sasha Ward obviously feels the same, for she says that her glass installation at the Great Western Hospital's Chaplaincy Centre "was only partly shaped by me"; she considered that the views of the building's normal users were just as important as her own as an artist.

I find it interesting that she is prepared to go so far, particularly as the commission was not established as a collaborative one, as in those cases when artists work with others to develop an imagery or ideas. And this leads neatly, of course, to the very vexed question of 'ownership', for just who is, or ought to be, the prime determinant of a work in such a context? Certainly I have encountered resentment among staff in some hospitals that an 'artist' is in any way more qualified to decide what embellishment is needed than they themselves—who regularly work in a place and use it in greater awareness of the tastes and pressures of its denizens. Jane Trowell, in a recent issue of the Royal Society of Arts Journal (February 2005), writes of the "fear of art" on the part of the powerful: quoting John Berger, she says art "makes sense of what life's brutalities cannot, a sense that unites us, for it is inseparable from justice at last". This statement resonates in connection with this commission. So, for very different reasons, does Trowell's further comment that in working in highly social contexts, as Sasha Ward did here, "it is essential for the artist to be highly informed and committed to the issue, otherwise their contribution will lack passion, rigour, and ultimately impact. 'Rent an artist' rarely works".

Certainly the essence of a commission of this kind is holding a balance (and it has been successfully held) between an artist 'merely' answering the perceived needs of the end users and the community in which the work has its being, and doing so in such a way that it is an integral part of their own practice—emotionally, aesthetically and philosophically. In this instance Sasha Ward succeeds in harmoniously reconciling her needs as an artist with those of a highly complex mixture of users.

I have encountered many wounded artists in situations where their art is not recognised as art, and altered by the addition of signage, for instance. And I was seriously challenged recently by one senior hospital manager to explain why my point of view was right, when I expressed despair at the, to my mind, bankrupt imagery of stick-on Disney Winnie the Pooh characters peeling from every possible surface of a children's day-room.

Perhaps in no other type of institution are questions of ownership of place and spheres of influence more complicated. Everyday difficulties of negotiating these are fraught, but of course become magnified several fold when any new build is in prospect. Then the competing professional interests achieve a level of complexity which makes the Treaty of Versailles talks a piece of cake! Hospitals are without doubt at the head of a list of society's most complex institutions; where else does one find such a combination of specialised purposes and simultaneous openness to such a wide variety of publics?

Amber Hiscott, atrium glasswork, 2002, The Great Western Hospital, Swindon

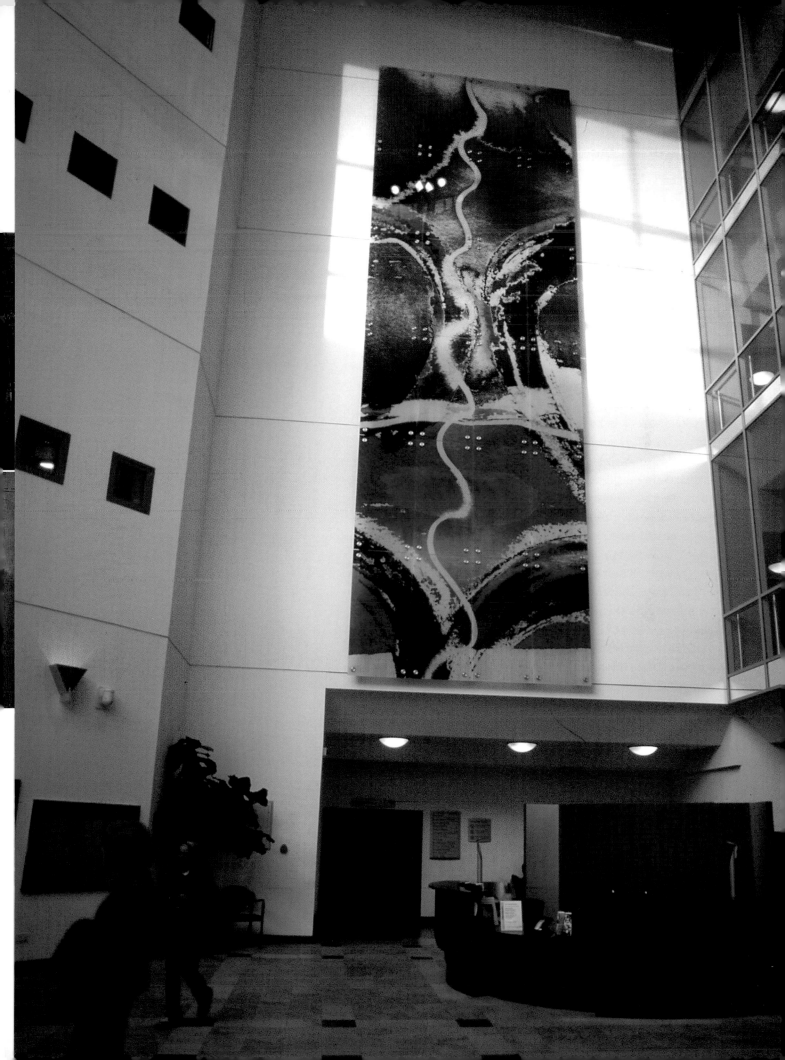

# Sasha Ward

*Hexagonal Camouflage*, 2004, limited edition artist's print

# Art and Science
## Simon Patterson at the Open University

"... while artists may be keen to immerse themselves in an understanding of complex scientific research, they must feel sufficiently inspired to push at the boundaries of their own current practice"

Siân Ede

# "To boldly go..."
## Simon Patterson

Any commission requires a leap of faith on both sides. This is even more the case when the artist, like myself, works in a variety of media and modes and whose contribution, therefore, tends to be unpredictable. It was clear from my first interview at the Open University (for a commission to create an artwork for the new building to house the Chemistry and Planetary Sciences departments) that I had been invited partly on the basis of a particular work for Warwick University, featuring a star map overlaid with the discography of the band Deep Purple. Despite this, the distinguished members of the interview panel, who together represented the two scientific departments, insisted that they were happy for the present commission to take me somewhere new. This was a great relief, since no artist is stimulated by the requirement merely to reprise earlier work.

I have been involved in a number of commissions to date, where only lip service has been paid to the idea of consultation. What was so new to me about this project has been the genuineness of the consultative process. Following the presentation of my work to the panel, and my subsequent selection, I was invited to give a more general slide talk to a wider audience. Though this was extremely daunting, it opened up the consultation process still further, so that I could speak on a one-to-one basis with faculty members, who were generous with their time and tolerant of my ignorance. This experience was enormously valuable to me, and helped to keep the flow of ideas free for as long as possible. This is vital, for I've found that initial ideas often have to be discarded later as being too obvious. During my slide presentation, I had already, foolishly, perhaps, promised representatives of both faculties that the work I ultimately produced would not be 'bad science'. Having painted myself into a corner, I now had to come up with a proposal that would be appropriate but not, I hoped, obvious.

Normally, I would have been very self-conscious about presenting what, from my point of view, was a very preliminary proposal. However, the atmosphere generated by the institution and faculty members made it easy for me to discuss ideas that were still at an 'experimental' stage of development. This process was also facilitated by the support given me at every stage by Bridget Crump at Artpoint. This support has become ever more necessary as the project approaches completion, especially given the need to coordinate with outside technological consultants and contractors. This is because I am working on a construction based on pulsars (dense stars), that involves not only manufactured structures but also light and sound elements that will be controlled by a computer programme.

As so often with new work or work in progress (for at the time of writing the commission is still at the design stage) it is difficult, at least for the artist, to see how it relates to earlier work. Equally, it is hard to judge how it differs from or extends my current practice. What is clear, is that given the level of support and trust I have enjoyed on this project, it is possible to push the frontiers and to boldly go where I haven't been before...

Previous
Simon Patterson, computer generated visualisation of *Gort, Klaatu barada nikto*, 2004, light and sound installation, Building 10, Open University, Milton Keynes

Simon Patterson, computer generated visualisation of *Gort, Klaatu barada nikto*, 2004

Professor John Zarnecki and Dr Ian Wright from the Planetary Sciences department with Simon Patterson, 2004, Open University, Milton Keynes

# *Gort, Klaatu barada nikto*
# —the Glamour of Science
## Siân Ede

It is perhaps unsurprising that Oxford based Artpoint should continue to play a significant part in what is a sometimes mystifying phenomenon, if not all the rage—the commissioning of artworks for science spaces. The motives of the science hosts are not always realistic. Aside from a general desire to provide an environment that is attractive to the eye and pleasing to the mood—and the therefore mistaken belief that art is principally there to decorate—they may express the hope that artists can successfully convey something about the intractably dense data being churned out at the place and thereby provide a route to willing public engagement, and consequently greater research funding and political approbation. But it doesn't work like that; and managing unreasonable expectations must be one of Artpoint's most challenging tasks. That they have got it right so often is testimony to their uncompromising belief in the integrity of art on its own terms and, moreover, in their commitment to ensuring that while artists may be keen to immerse themselves in an understanding of complex scientific research, they must feel sufficiently inspired to push at the boundaries of their own current practice. Artpoint's mediation ensures that artists' professionalism is respected and their artworks 'understood' on many levels. Indeed, this is rather sly of them. It is art that is demystified in the process, though the science may benefit in unexpected ways.

Jem Finer, sketches for
*The Centre of the Universe*,
2004

Art/science projects established by Artpoint have involved Wenyon & Gamble's residency at the Rutherford Appleton Laboratory, Chilton and the UK Atomic Energy Authority, Culham; and Ackroyd & Harvey and Catherine Yass's residencies at the Sir William Dunn School of Pathology, Oxford University. The organisation is currently working with Jem Finer, artist in residence at the Department of Astrophysics at Oxford University, on a series of public projects which have developed from his research in the department. All of these projects have resulted in new works which reflect on the social context of scientific discovery. Wenyon & Gamble's photographs present a dizzying hyper-real spectrum of scientists at work; Heather Ackroyd and Dan Harvey's slate and grassy gardenscape provokes a contemplation on the science of natural processes and cell structures, even as visitors seek relaxation in its presence; Catherine Yass's work stimulates the viewer to find in scientific paraphernalia an arcane mystery that is almost sinister; and Jem Finer constructs a working wooden radio-telescope to elicit from the citizens of Oxford a reconsideration of the nature of Space, both in the locality and in the wider universe.

PLAN

ISOMETRIC (DISH OMITTED)

ISOMETRIC VIEW

ELEVATION

SECTION A — A

DETAIL X

DETAIL Y

atelier one

atelier one, architectural
drawings for *The Centre
of the Universe*, 2004

Some art/sci works demand close collaboration. In 2000, Catherine Yass undertook a year long residency at the Sir William Dunn School of Pathology in order to experiment alongside Dr William James. Dr James works on nucleic acid shapes that complement the form of pathogens and illustrates them in the form of digital pictures that are artificially coloured to reveal how the shapes interact. He was seeking to refine his coding techniques in order to more precisely interpret his observations and thereby learn to recognise the boundaries between aesthetic preference and logical scrutiny. Yass's aim was to observe the scientist's rigour in making and measuring fine distinctions in connection-making. Each learned from the other while maintaining the integrity of their disciplines: James striving to negate human agency from his interventions so he could find objective meaning, and Yass bringing a trained aesthetic sense to rearrange, distort and fine tune in order to create new photographic artworks, charged with her characteristic eerie colour saturations, which convey her unique take on the world. Re-interpretation seems to be the key for both sides, not literal translation.

"Do not forget that a poem, even though it is composed in the language of information, is not used in the language-game of giving information", Wittgenstein wrote (in *Zettel*).[1] While this thought may be applied to any work of art which transmutes and thereby transforms the normal function of any material, it is particularly so in the case of works which actually use language, as so many conceptual contemporary works do, if only in their ambivalent titles. Simon Patterson has appropriated rational or scientific systems and codes—maps, charts, grids, tables, lists—and bestowed on them his own subverted hierarchies of association. The works are visually captivating in their own right: large, highly coloured, a celebration of order and precision, with particular care given to

1 Wittgenstein, Ludwig, *Zettel*, second edition, G E M Anscombe & G H von Wright eds., Oxford: Blackwell, 1981, p. 568.

Catherine Yass, *Double Agent* (detail), light box, 2001

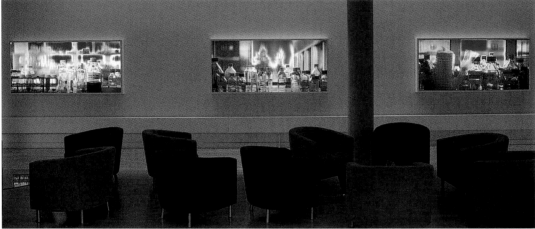

Catherine Yass, *Double Agent*, 2001, light boxes, common room, Sir William Dunn School of Pathology, University of Oxford

Wenyon & Gamble, *The Quiet Sun*, 2001, mosaic of 50,000 glass tiles based on the solar spectrum, White Horse Leisure and Tennis Centre, Abingdon, a commission developed from the artists' residency at the UK Atomic Energy Authority and Rutherford Appleton Laboratory

Wenyon & Gamble, *The Quiet Sun* (detail), 2001

# The Great Bear

Simon Patterson, *The Great Bear*, 1992, four colour lithograph. Reproduced courtesy of the Lisson Gallery

preserving authentic layout and type-face. But, with a flourish of incongruity, they contain names, words or terms derived higgledy-piggledy from both received canon and popular culture. In his well-known Underground map, *The Great Bear*, 1992, the familiar stations have been replaced by lists of famous people—engineers, explorers, Italian artists, 30 comedians, and so on. In his versions of Mendeleev's 1860s Periodic Table, 1994-5, the elements represent names of the illustrious (35 Br = Bertolt Brecht) or more absurdly random terms (37 Rb = Red Buttons). In *First Circle*, 1996, he appends the names of utopian lands—Xanadu, El Dorado, Shangri La—to a large coloured map of elliptical planetary orbits. The lists are of Patterson's personal favourites, grounded in the cultural connection-making of our media-driven times—popular heroes, stars of past and present, obsessive 'best of' series—all endowed with a comic quasi-scientific gravitas by their punctilious systematics. In the tradition of word games, crosswords, playground songs or nonsense verse, formal structures serve to highlight the ridiculousness of chance association. Meaning and sound inter-relate almost, but not quite, by accident, as if a kind of synaesthesia is at play, a crazy cross-wiring of neural connections, simultaneously haphazard and intelligent, mellifluous and banal. Reason becomes literally ludic and therefore ludicrous. Patterson has Celtic connections and keen literary and operatic interests, and there is something particularly British—from Alexander Pope to WS Gilbert,

Simon Patterson, *First Circle*, 1996, wall drawing, Tate Gallery, London

Lewis Carroll, Monty Python, the Two Ronnies and, latterly, many conceptual artists—in taking pleasure from word-play and naming games, with assonance and punning, as part of an established tradition of mock-heroism. Pompousness is punctured but, more profoundly, bathos hints at pathos and an intimation of the certainty of death hovers even in the face of scrupulous Platonic order and optimism.

Patterson's work derives from a post war, cold war, phoney war consciousness, but it contains an enchantment too—the self-conscious glamour of the B movie, war films, westerns and sci-fi fictions with their super-clean heroes and malevolent villains, their cod-authoritative diagrams and clunky technologies representing their audiences' hopes for an ethically cleansed silver-clad future in a universe of twinkling stars.

The Open University has commissioned Patterson to make a work for a new building, designed by architects Ridge & Partners, for its Chemistry and Planetary Sciences Departments. The two departments, represented in this project by Dr Lesley Smart and Professor John Zarnecki, work closely together and have been engaged in a project of astounding boldness, the culmination of a seven year, two billion mile journey to Titan, one of Saturn's largest moons, in which the Huygens probe, hitching a ride on NASA's Cassini spacecraft, plunged into the atmosphere of the methane-clouded world, which may turn out to be a remote, frozen version of early Earth and therefore a likely stimulus for theories—or fantasies—concerning the origin of life, or even of alien forms.

The project is beguiling to Patterson, who as a small boy was entranced by Patrick Moore's TV astronomy programme *The Sky at Night*, and moved by the presenter's occasional matter-of-fact observation that, "of course, I won't be around to see that", making only too evident the enormous empty scope of time and space in the universe and our humble attempts to understand it. The Open University work is to be sited at the entrance to the sci-fi sounding 'Building 10' (it has yet to be officially named), which houses

offices and laboratories. Inspired simultaneously by the vast ambition of the research on hand and the sense that such daring technology inevitably has a Heath Robinson element to it, Patterson has turned to flight adventure movies. He envisages a runway of light and sound running diagonally up to the building's entrance. This is delineated by a series of airfield approach lights set upon bright yellow pylons and arranged in steep perspective of descending order, with the highest starting on the edge of the site, and the lowest immediately above the entrance or 'landing threshold' (in the compelling jargon of air traffic control). Blue 'elevated taxiway edge lights' are set at appropriate intervals as are flashing yellow 'elevated runway guard lights', normally used to warn pilots that they are approaching a runway holding position. A ground level light box warns pilots/drivers of the 'Runway Ahead'. The runway is convincingly accurate but it is also clearly a fake, a filmset, scaled down for normal life (indeed, the residents might be otherwise irritated, or, worse, local aircraft might misread the signs). It actively performs, however, and presents a discontinuous sequence of light and sound events, triggered by a movement sensor, which responds to the frequency of people passing through. The audio projections, created by sound designer Fergus Rougier, transmit 'corridors' of sound taken from recorded radio signals from pulsars in space, and a solar-powered control box activates the lights and sound to mimic the way landing lights are switched off and on as aircraft approaches.

The care with which the model runway is to be constructed, using genuine airport equipment, is characteristic of Patterson's adulation of form and formality. But while it reflects a *Boy's Own* romance with engineering it points, too, to the rapidity with which apparently futuristic technologies so quickly acquire a period charm. Redundant technology, Patterson says, "is often more interesting than anything you're going to make" and he loves the idea of "making useless objects resonate". He mentions a conversation with one of the planetary scientists who described breaking off a car windscreen wiper device and adapting it for rocket use. This, then, is a celebration not of a scientific quest for the beauty of knowledge and mechanical elegance but of "quite ugly objects, things you normally ignore" put to ingenious new use, sometimes for real, in this case for sham. There remains, however, the allure of romance, the drama of flashing lights and mysterious sound pulses, a reference to the flying saucers and airport chases of the movies and their stories of heroism in the face of danger, their ultimate desire for reconciliation and peace. The ambiguous term 'landing light' suggests a return to the security of home through the blackness of night, of frightening gravity-defying journeys coming to a reassuring end. Punningly, one is also reminded of the child's request to leave the landing light on in the dark. And it implies an arrival unencumbered by the baggage of responsibility, of being light-hearted, fantastical.

Patterson's title is *Gort, Klaatu barada nikto*, a line from the 1951 movie, *The Day the Earth Stood Still*, which tells the story of a humanoid spaceman who comes to Earth to convince its leaders to learn how to live in peace.[2] The mantra "Gort, Klaatu barada nikto" is spoken by the earthling heroine, on the instruction of the benign spaceman Klaatu, to persuade the robot Gort to cancel its attack on Earth, a task she manages to undertake just in the nick of time.

Patterson's artwork is daring and witty and will hopefully regularly raise a smile at its workaday location. Technically hyper-efficient but pointless, it is affectionate in its regard for human invention and achievement. While apparently—and flatteringly—mimicking the ambitions of science and technology, it seems to communicate the deepest of human desires reflected in both art and science—to boldly go on seeking for meaning and purpose, whether in the wider universe or in the recesses of the human mind. And it cherishes the importance of maintaining an adventurous fantasy life.

2 *The Day the Earth Stood Still* was directed by Robert Wise; the score was written by Bernard Hermann and included the first use of a theremin in movie background music.

# Simon Patterson

*Escape Routing Storyboard* (detail), 2005, limited edition artist's print

Place the mask over your mouth and nose, like this, and breath normally.

Along with handcuffs and neck irons, there are special types of metal collars made to lock about a person's neck and from which escape is seemingly impossible.

# PLEASE DO NOT REMOVE FROM AIRCRAFT

# Architectural Collaboration
## Jacqui Poncelet at Didcot Arts Centre

"I still see the whole process as a dialogue between the artist and architect."

Dominic Williams

# A New Arts Centre for Didcot
## Jacqui Poncelet

*Since 2001, artist Jacqui Poncelet has been working with architect Dominic Williams on the design of a new arts centre for Didcot, Oxfordshire.*

Previous
Ellis Williams Architects
(EWA), designs for Didcot Arts
Centre, 2004

Thinking about places.

Designing a place within a place.

Looking at places with new eyes.

Thinking about people.

Watching people.

Listening to people.

So many different kinds of people, so many different agendas.

Thinking about how architects must also be politicians.

Wondering how buildings ever get built.

Listening to Dominic, Dominic listening to everyone.

Laughing.

A lot of laughing about the craziness of it all.

The pleasure of ideas.

The infinite possibilities and endless optimism.

The thought of making a difference.

Speed.

Ideas, so many ideas, ideas developing fast within a team.

Ideas handed on, growing or being dismissed, no individual ownership.

The freedom to let one's mind wander.

Decisions made, decisions changed.

Jacqui Poncelet with EWA,
design for seating
incorporated into cladding,
2002, cardboard model

Jacqui Poncelet, cardboard
sketches exploring cladding
design, 2002

Left
*Lights On*

Right
*Corners and Colour*

Below
*From Straight to Curved*

Jacqui Poncelet in
collaboration with architect
Tom de Paor, design for
Renwick Road underpasses,
2002, A13 Barking

Jacqui Poncelet,
*Men's Carpets*, 2001, acoustic
panel made from tufted wool
carpet, Ocean Music Trust,
Hackney

Slowness and waiting, waiting for decisions from outside the team.

So many things to think about.

Too many things for one person to think about.

One group creates, another group rejects.

The expertise of others.

Some reassuring constants.

Startled by the turnover of Arts Officers.

Startled by the turnover of Councillors.

Startled by the turnover of buildings.

How do architects stay sane?

Scale: from large to small/from small to large.

Detail: from the general to the particular.

Design: from inside to outside.

Stuff: coloured, textured, reflective, transparent, opaque,

flat, bent, pleated, stuffed.

Places for looking, listening, performing, eating, drinking, speaking, laughing,

sharing.

Looking to do the best with the budget.

The pleasure of a cardboard model, all potential and no compromise.

The pleasure of a sample, manageable and free.

A hundred small rewards.

Thinking about windows in new ways. Why make a window and then cover it up?

Thinking about consultation. What are the appropriate questions to ask?

Thinking about expectations, the whole variety of them.

Using experience and gaining experience, a pleasure that can't be untangled.

Jacqui Poncelet, *Windows and screens*, 2002, composite of ideas for Didcot Arts Centre

Jacqui Poncelet, *Weave* (detail), 1999, photographic collage from *a stranger here myself*, Camden Arts Centre, London

Jacqui Poncelet, *Who knows?*, 1994, oil on canvas, fabric, photography, from *Blue and Green Should Never be Seen*, Angel Row Gallery, Nottingham

Above
EWA drawing of east elevation of Didcot Arts Centre showing location of windows, 2003

Middle
Jacqui Poncelet, sample of etched and mirrored glass, 2003

Below
EWA drawing of windows onto rehearsal space showing the artist's etching proposal, 2003

Jacqui Poncelet with EWA,
*Colours, Textures, Curves*,
2002, cardboard sketches for
cladding

EWA, model of Didcot Arts
Centre, 2004

Design team meeting, Richard
Layzell (Resident Artist) and
Jacqui Poncelet (Consultant
Artist), 2002

Dominic Williams (EWA),
designs for Didcot Arts Centre
elevation from the north east,
2004

# Reflecting on Working with Jacqui Poncelet
## Dominic Williams

I first met Jacqui in September 2001 following my invitation to her to visit our Clerkenwell studio. I think the meeting was intended to be a final review following a committee selection process, but thankfully it resulted in a progressive discussion about the project— the design of a new arts centre for Didcot, South Oxfordshire. Her interest in surface montages and scale distortion certainly interested me, and I liked the work I had seen before. Jacqui had been selected to join our team as Consultant Artist for the new arts centre, which would form a focal point in a new town centre development. She also had a further brief to develop a work, or indeed interface with the architecture. At that time we were just in the exhausting throes of completing the Baltic project on site, so I remember the meeting was a refreshing change for me, allowing conceptual thinking again, and wide ranging discussion with Jacqui.[1]

I remember that not long after we managed to visit Didcot together, and perhaps the faint reality of this place helped us both fix on the idea that there was an opportunity for this new centre to be and appear different, despite knowing the difficulty we might have with the planners. It is a town that has developed along a main trunk road with no real centre apart from a railway station and the very visible power stations. The predominant material is brown and red brick, interrupted by chaotic displays in the numerous charity shops that line the main boulevard, and I guess it was these which indicated that a change was just in time for the growing younger population.

The idea from the first visit was to choose a material for the building that would be different and fresh, and then use the material to make gestures to the limited urban spaces. I think Jacqui picked up on some of the social difficulties in attracting younger people to such a facility, so we spent some time in the various 'non-spaces' around the site, particularly where local skateboarders hung out and sporadic shoppers passed fleetingly. Our client was South Oxfordshire District Council so, ultimately, we had no single end user as such. I was not unused to this situation where one practically relies on alchemy in order to create a new building for an unknown group of people. Along with an arts consultant who was responsible for the draft brief and initial public consultation, Jacqui was enormously important in the discussion of how the organisation of arts spaces could work best. The brief contained a democratic mix of art media workshop spaces, a main performance space and social facilities. One particular discussion was about a disenfranchised youth stepping over the threshold and wanting to participate in one of the art workshops. The journey of such a person through the notional diagram of the building became one of many topics considered and reflected on with Jacqui. Indeed, it is this understanding that an artist can bring which is of value to a design team, as it is they who have the working experience of art creation and activity in spaces.

In the long run, we ended up collaborating on two very different approaches for the site, both quite different also in their content. The initial scheme ran aground due to cost issues and a political change in the Council, leading to the brief being rewritten and re-consulted, and an inevitable pause in the project. When the project resumed, the floor area was

1 The Baltic, a contemporary art gallery for Gateshead, created from a converted grain store, opened to the public in 2002.

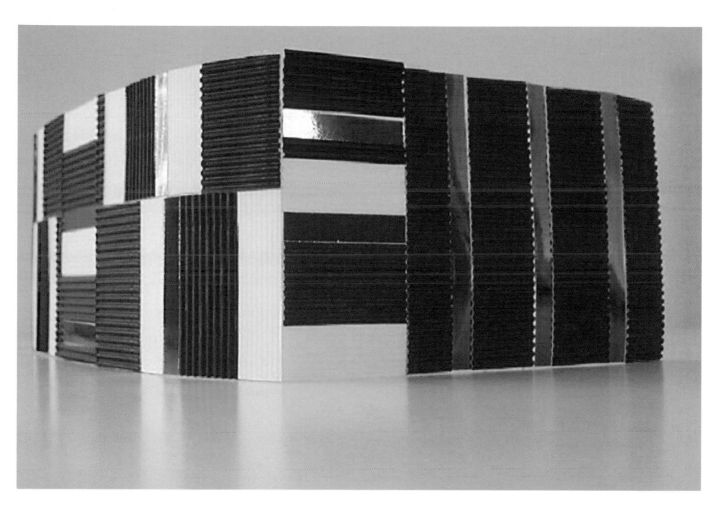

Jacqui Poncelet with EWA,
cardboard sketch showing
cladding proposal, 2002

reduced by one third and we had to move away from the concept of open and organic, to an orthogonal and more spare organisation. The fact that Jacqui remained enthusiastic throughout this upheaval was a great boost to the design team. I think another difference now was that we needed to be more focused and efficient in the second scheme, and our developed working relationship helped the collaboration. I don't wish to explain the differences of the two schemes in detail, but to allude briefly to Jacqui's input in terms of her creative role along the twisting path.

Early on we had considered a variety of materials to clad the building. Often Jacqui would bring photographic snippets of detail, relevant to this aspect of the building, to discuss; I would often, in turn, react with sample materials or swatches. Jacqui became very interested in the treatment of the building's outer skin and we agreed that her work would be in essence distributed around the faces of the building. We finally decided that the primary cladding material should be aluminium as there were a number of ways panels created from this material could be fabricated and assembled. We also thought that if colour was to be used, the natural range of colours achieved by anodising aluminium would be good from a maintenance angle. This material thus offered many options and seemed to fit with both our ideas and our way of working.

Jacqui began to work with a selection of coloured, plain and textured card, creating a test base for how the cladding might also negotiate angles and curves. During discussions on how the building could deal with different situations on site, she became very interested in how the windows would work and also the effects of light and colour on scale and angle. One example was the development of the folded window planes that could either provide shading or privacy, depending on the location of the window. I think the key issue

Jacqui Poncelet with EWA,
design for acoustic panels,
2005

Dominic Williams (EWA),
visualisation of café and foyer
areas with acoustic panels,
2005

Dominic Williams (EWA),
drawings for 'petal' windows,
2002

Dominic Williams (EWA),
visualisation of Didcot Arts
Centre at night, 2002

Dominic Williams (EWA), proposal for perforated panels, 2002

throughout the whole thought process was the site's north facing orientation due to it having to adjoin to the south and provide a main frontage onto the new town square. This made us think very carefully about how any direct sunlight could be captured using different textures and facets. The use of colour could also offset orientation and, interestingly, this underpins the various scheme transformations in different ways. A series of details was thus developed, evolving a language of parts. One of my favourite details was Jacqui's idea to create a seat from the cladding, with an aluminium panel that had in effect slipped out of place to form a curved seat positioned on one of the routes around the building.

Much of our early discussion was about dealing with public spaces in and around the building, and how materiality can effect people's perception of their environment. These concepts are not new to designers, but the question is how you communicate with a large group of people who have never thought in this way before. Jacqui attended a number of presentations to the Council and local residents, and I believe she provided a unique voice to connect with the audience through a combination of open questioning and visual props. The boxes of folded card maquettes and samples became very well travelled and were almost an act of consultation in themselves when passed around. I remember that one Councillor thought that a space ship could be landing in central Didcot in the not too distant future. I thanked him for his compliment, thinking at the time that a sense of fun and enjoyment would be a new currency for this place, and that Jacqui had recognised this from our first visit.

I still see the whole process as a dialogue between the artist and architect. During its various evolutions the design had to react to external factors in many ways, including a

significant re-design after the Council re-shuffle. Politics were an inevitable context for this project and it can take great patience to deal with issues that are thrown out of this melting pot. Does there come a point where it is impossible to produce a resolved and good work? I hope this is not the case! However, thinking time—of which we had plenty—is vital. The language of parts that we developed also had to change, and the fundamental form of the building twisted within the confines of straight lines and away from its original curves.

However, in the latest scheme there are echoes of those early conversations with Jacqui. The panels are now folded and perforated to catch the light, to project life and texture, onto faces of the building that have a limited percentage of sunlight. Jacqui has reacted in a beautiful and contextual way and we now wait for the real size prototypes being prepared with an eagerness to refine them. Large areas of anodised colours were limited by cost but we have managed to afford small areas of colour on the large glazed window cowls, which will reveal themselves as one passes by the building. The tube-like rectilinear structures of the building which are organised to contain the various spaces for the arts centre, are orientated and bent, opening onto, or turning away from, the surrounding public spaces; I think this was a final response to our early dialogue on windows. Some of the aluminium panels will be perforated and backlit with Light Emitting Diodes (LEDs), and will be designed in collaboration with local young people, through a schools project run by Richard Layzell, the Resident Artist for the project, who has a remit to involve the local community in the building's development. The unknown results of this potentially chaotic gesture I think excite and scare us both in equal measures and embody the spirit of fun, which I believe still pervades the project.

Another facet of our conversations related to interior materials, and this, in turn, has led to another approach in the realms of limited finishes options and exposed ceilings. The main spaces will require vital acoustic treatment and the intention is to hang simple absorptive fabric panels, which in turn will also create visual linkage and references to the building form and envelope. Needless to say, Jacqui has thrown herself into considering this element of the building with the same enthusiasm that she had back at the beginning of the project.

Jacqui Poncelet
*wish you were here*, 2004, limited edition artist's print

# Responding to Architecture Alison Turnbull at Milton Keynes Theatre

"The historical and conventional assumption that the role of the architect is to create form and that the role of the artist is to decorate form has in many recent public art projects been critically challenged." Michael Stanley

# From Mondkarte to Milton Keynes
## Alison Turnbull

The starting point for *Moon* was an engraving published by the Bibliographisches Institut in Leipzig in 1894, given to me 100 years later, on my birthday in 1994. I didn't envisage then that I would soon be magnifying it 28 times and transposing it onto the walls of a new theatre in Milton Keynes.

The engraving measures 24 x 30 centimetres and has been dated in the top left corner, in careful copperplate writing. On yellowing paper, probably a plate torn from a book, it depicts a detailed image of the moon and lists the names of 188 craters, rills and other features of the lunar surface, from the Acherusia Cap to the Zagut crater. Before making *Moon*, the found drawings I had employed in making my paintings had all been strictly architectural: building plans, sections and elevations. In fact, I would have said that architecture—albeit in the wide sense of how we transform the spaces we inhabit—was the reason for choosing them, and that the function and physical reality of the drawings were secondary. Now I would certainly reverse that hierarchy, or dispense with it altogether.

Drawing and the many ways it is employed across disciplines, both as a blueprint for the future and as a means of deciphering the past, has become increasingly important. I have worked with an Internet map of Tokyo's Narita airport, block-like plans of a zoo and two hospitals from a 1911 map of Calcutta and, most recently, scientific and horticultural drawings used by the botanic garden in Oxford in the process of changing the arrangement of their plant collection from a system based on plant morphology to one based on molecular data.

In February 1999 I visited Doug Daniels, a retired astronomical imager, in his home in north London to see the telescope installed in his back garden. I wanted to show him my working drawings, to ensure that any distortions that had occurred in the passage from found engraving to scaled up drawing hadn't made my representation of the moon topographically inaccurate to any serious degree. Doug also explained how a draughtsman would have made the Leipzig *Mondkarte,* sitting alongside an astronomer at a telescope, meticulously plotting what was being described onto a paper grid. The process that was used, over a century later, to transfer the moon map to the walls of the theatre in Milton Keynes was remarkably similar. But the material I drew onto (up a scaffolding tower with my small team of lunar draughtsmen) was fair-faced concrete. It is a surprisingly sensitive and even surface to work on.

Just as the sources I use have expanded to include drawings relating to astronomy, cartography and plant science, the grounds of my paintings have become both more varied and more specific. Sometimes the paint is flat and unobtrusive, like a smooth sheet of paper; at others it is built up in dense layers of tiny coloured brush marks. But whereas in making paintings it is the drawing that is the found object and the surface that demands my attention, in *Moon* the concrete surface was given and it was through the act of drawing that the process of transformation took place.

Previous
Alison Turnbull, *Moon* (detail), 1999, graphite and ink on concrete, Milton Keynes Theatre

Alison Turnbull, drawing for *Moon,* 1999

Alison Turnbull, *Moon,* 1999, Milton Keynes Theatre

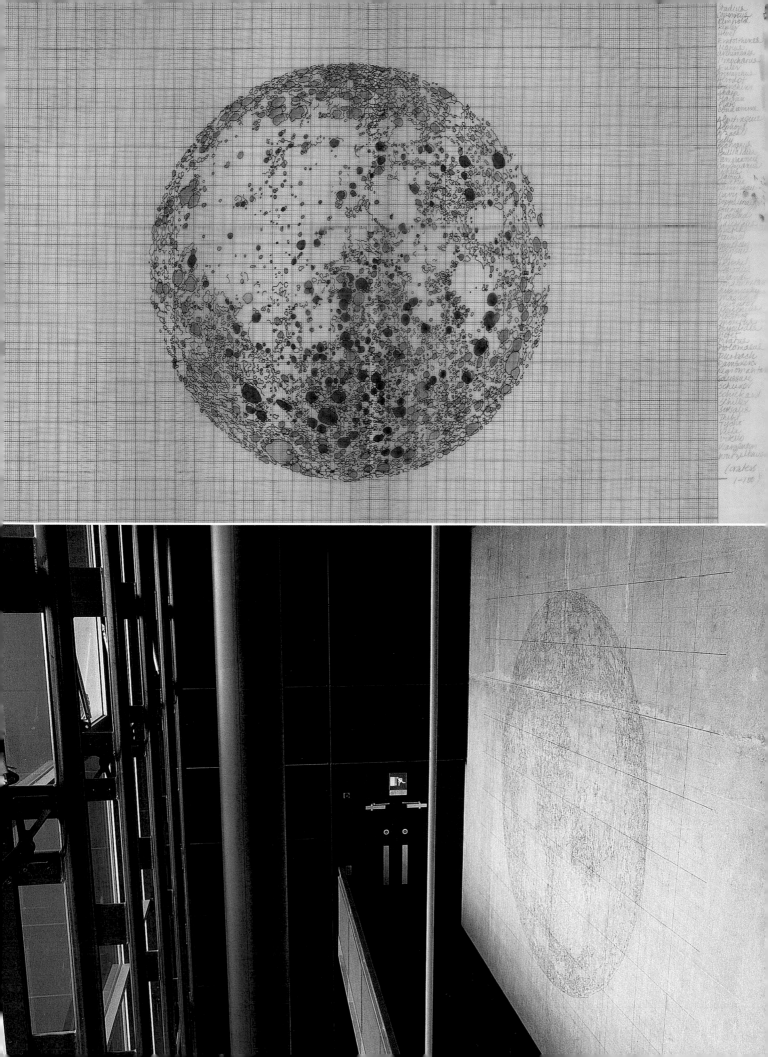

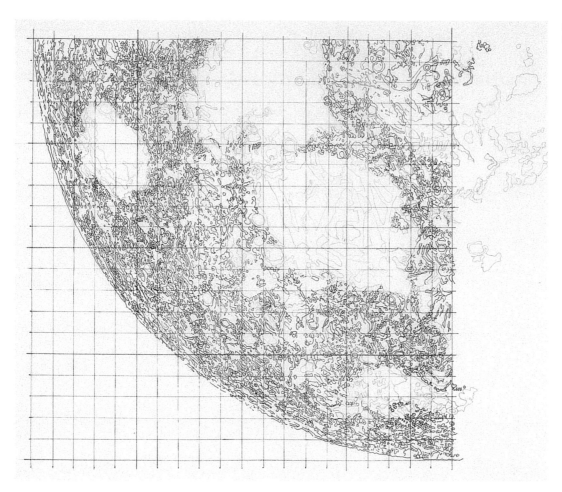

Alison Turnbull, working
drawing for *Moon*, 1999

Alison Turnbull in her studio
with working drawings for
*Moon*, 1999

The artist's studio, including new work based on the Botanic Garden, Oxford, 2004

Alison Turnbull, *Hospital Calcutta (Eden)*, 2002, oil on canvas on board

Alison Turnbull, *Airport*, 2000, oil and acrylic on canvas on board

Alison Turnbull, *Lighthouse*, 1997, acrylic on canvas on board

# Moonlandings
## Michael Stanley

### Preamble

Drawn in black ink and graphite and appearing as if etched into the very surface of the bare concrete wall that supports it, Alison Turnbull's wall drawing *Moon*, 1999, for Milton Keynes Theatre is a stark proposition, its presence fugitive, almost 'intangible'. For the commission Turnbull, working with a team of two assistants, transferred a detailed blueprint of the moon's cratered surface onto the concrete wall of the theatre's fly tower. The drawing, enlarged through countless processes of 'squaring-up' and transposed by hand, brings a distinct human dimension to the otherwise mechanical process of construction. The familiarity of the concrete pitted surface references the imagined lunar landscape that it echoes—it is a playful usage of image, material and object, at once alluding to the celestial heavens and at the same time to Earth's molecular reality.

Michael Craig-Martin, *Untitled*, 1999, laser-cut stainless steel, Milton Keynes Theatre

*Moon* is one of a number of commissioned wall drawings for the Theatre curated by artist Edward Allington and comprising work by a range of artists, including Lily van der Stokker, Michael Craig-Martin and Estelle Thompson. The very idea of literal projection, of aspiration, of suspending disbelief and 'star-gazing' can all be surmised in Turnbull's response to the theatre context. Consciously or unconsciously, amongst the variety of characters performing in the theatre space, *Moon* takes on a distinct persona—it is the Greek Chorus, poignantly commenting on the central action, curiously moving events along with each orbit of the Earth and embodying a permanent though sometimes elusive presence.

### Milton Keynes

Responding to the context of Milton Keynes Theatre is an intriguing challenge. The Theatre itself is not only a new-build, but a new-build in the UK's most newly-built town—Milton Keynes. Opening in 1999, the new Theatre, together with the new Gallery, and Theatre District, were plugged into the pre-existing grid plan of Milton Keynes to deliver the arts and cultural provision for the developing city. 30 years earlier, 1969, as the first man walked on the moon, the first wave of construction on the newly designated New Town that is Milton Keynes began. Ingrained in these nostalgic recollections is the aspiration and infectious utopianism that was to fuel a generation. The cartographic mapping of the lunar surface, the charting of new territory embodied in Turnbull's project resonates with the *tabula rasa* that faced the designers of the masterplan, itself the result of graphite on paper, as ideas were enthusiastically sketched, erased, re-worked, collaged and re-mapped on the drawing board. An archival,

Estelle Thompson, *Midsummer Set*, 1999, acrylic on aluminium, Milton Keynes Theatre

Helmut Jacoby, imagined aerial view of Central Milton Keynes, created as the city was being built, 1970s © English Partnerships, with the kind assistance of the Commission for the New Towns (operating as English Partnerships)

aerial photograph of Central Milton Keynes taken from this period, showing the cratered and scarred surface of the red earth as bulldozers ambitiously altered the physical environment, is distinctly 'otherworldly'. In this context, Turnbull's gesture to map onto architectural reality the blueprint of the unfamiliar moon landscape, a place predominantly experienced through the distanced mediation of a scientific journal or telescope, brings together the artist's continuing engagement with illusion and material reality—a vein that runs deep throughout her practice.

## Concrete

Milton Keynes is the 'concrete city'—concrete is to Milton Keynes what granite is to Glasgow, limestone is to Portland and chalk to Dover. Concrete has become synonymous with the external perception of Milton Keynes, derived from the swathe of largely concrete structures that make up its skyline. Such is the abundance of concrete structures in Milton Keynes, its walkways and underpasses, that the phenomenon of intentional mark-making on a bare concrete surface from tagging or graffiti is, as in many other major towns and cities, a familiar and distinct part of the urban experience. That Turnbull has chosen to work directly on concrete itself playfully connects with the specific context of the host city, reclaiming and liberating the material from its previous associations. Where Turnbull's project differs from the everyday experience, however, is in its almost subversive attempt to tonally camouflage itself—grey on grey, graphite on graphite—becoming almost imperceptible. *Moon* is not an invasive proposition that loudly announces itself to its audience, but instead it waits patiently to be discovered.

## Not singing and not shouting

In many respects the modesty inherent in *Moon* goes some way to subverting the anticipated relationship between artist and architect and between public artwork and public space. The historical and conventional assumption that the role of the architect is to create form and that the role of the artist is to decorate form has in many recent public art projects been critically challenged. The advocacy of a closer working relationship between artist and architect at the outset of project development, and the role of the artist as consultant or advisor, has gained common currency—Michael Craig-Martin's profitable collaboration with Herzog and de Meuron in the creation of the Laban Centre, or Richard Wentworth's substantial intervention with Caruzo St John for the New Art Gallery, Walsall are notable examples. Despite the artist's close working with the architect Andrzej Blonski, it would seem that Turnbull's *Moon* returns to the traditional artist/architect model, but only to undermine it.

Alison Turnbull, *Moon* (detail), 1999, graphite and ink on concrete, Milton Keynes Theatre

*Moon* makes problematic the idea of the decorative. It adorns the base material of concrete that acts as its ground and support. However, the decorative is manifest in a sober palette of graphite and black, so that the trace of lines is hardly noticeable and the very idea of 'decoration' is subverted. The lines are fragile on the plane of the concrete, appearing as though they have been brought to its surface through an alchemical process from deep within the material core—as fault lines or seismic plates. So much so that the work does not sing nor shout nor seek applause as on centre stage, but modestly asserts its presence in a contemplative gaze. Experiencing the work is equally elusive, the architecture denies the viewer the opportunity of stepping back to take in the entirety of the whole, instead we take in fragments as we move through the space of the theatre balcony. Fittingly, in the same way that the moon reflects the light of the sun, the only way in which the viewer can visually experience the whole is in the reflections gleaned at night time in the glazed surfaces of the building's exterior. Here the viewer magically becomes part of the whole spectacle, absorbed by the halo-like surrounding image.

## Permanence

The very idea of permanence is questionable in relation to public space and public buildings, specifically in a culture in which the tendency to tear down and re-build is prevalent. The question of permanence is real and challenging, particularly in the specific context of Milton Keynes where decisions about the rapid growth and expansion of the city are debated daily. Intriguingly, two of Turnbull's architectural commissions—Milton Keynes Theatre and Bellgrove Street, Glasgow—have been described as 'permanent', and it is interesting how the artist, when responding to this challenge, has chosen to work with both the fundamental form and function of the building.

At Bellgrove Street, Turnbull's installation of brightly coloured lamps in the five stairwells of each apartment block—turquoise, red, blue, amber and green, each activated as the natural light faded—ran like a rainbow down the length of the street. It is true that these works are not inherently permanent; lights in the stairwell could be de-installed and the artist's painting erased from the concrete surface of the theatre's fly tower, but the

Alison Turnbull, *9-15 Bellgrove St*, 1996, light fittings and glass filters, Glasgow

very idea of a stairwell without lighting or the theatre without its central concrete support suggests how closely wedded with the architectural form of the building Turnbull's projects are. To remove the artwork is to remove the building, suggesting maybe the apocalyptic image of the theatre turned to ruins and the piecing together of thousands of shards of concrete each etched with Turnbull's distinctive moon imprint.

These ideas not only apply to Turnbull's commission for Milton Keynes Theatre but resonate emphatically with her studio practice and ongoing research into the phenomenology of architectural space. The relationship between Turnbull's studio work and her public commissions is an ongoing process that reciprocally informs and compounds the other. Turnbull's paintings are distinctly archaeological, relying on studious periods of intense research and investigation. Her recent series of paintings, *Houses into Flats* and *Hospital,* are based on, often historical, floor plans of public institutions: churches, prisons, hospitals and public swimming pools. They are at once embodiments of potential, the excitement of an architect's visions, and fragments of a never-to-be-retrieved past.

# Alison Turnbull

*Botanic Garden*, 2004. limited edition artist's print

# Designing Places
# Thomas
# Heatherwick
# and Central
# Milton Keynes

"... artists have something unique to contribute to place making, not as an adjunct to development, but by leading development in a new direction"

Chris Murray

# Square Watermelons
## Thomas Heatherwick and Maisie Rowe

At work today at Thomas Heatherwick Studio are five architects, two product designers and a theatre designer, a structural engineer, a project manager and a landscape architect—and Thomas Heatherwick, who trained as a three-dimensional designer. There have been three artists working at the studio... in ten years, out of more than 100 employees and interns. So, we aren't artists. Why then are we in a book entitled *Artists and Public Space*?

Previous
Thomas Heatherwick Studio, model of *Info Box*, a proposal for Central Milton Keynes, 2003

It is because, in 2001, Thomas Heatherwick Studio was invited to produce a paper that would address the future role of public art in Central Milton Keynes (CMK). CMK was reaching the end of its first 30 year plan, and was in the process of masterplanning its development over the next 30 years; our strategic paper, entitled "Public Art in Central Milton Keynes", was commissioned as part of the new Development Framework for the city centre.

We looked at CMK and saw a city centre conceived and built in one bold step, a celebration of human ability to shape the environment. As a complete and total vision, a whole new city built almost from scratch, Milton Keynes made its own rules, creating a heritage of innovation, clarity and single-mindedness. This self-confidence came through in the rectilinearity of its planning, architecture and landscape, which at CMK is a consistent aesthetic and functional language that is echoed at every scale, from the grid plan layout, through the buildings themselves to the design of the landscaping. In contrast to the haphazard spontaneity of the traditional, layered city, CMK makes a deliberate statement, like Brasilia, Poundbury, Las Vegas or Florida's Seaside. Love it or hate it, the consistent application of this singular vision has made a city that is a product of artistic thinking: a work of public art in its own right.

Square watermelons: Rectilinearity: a celebration of humans' ability to shape their environment

In 2001, every other city seemed to be undertaking masterplanning exercises, competing with each other to be more 'distinctive', but pursuing distinctiveness in similar ways: pedestrianised streets, iconic galleries, squares and piazzas, flower stalls, street entertainers, cappuccino shops. Simultaneously, CMK appeared to be losing confidence in itself, coming adrift from its heritage of innovation and originality. Its recent additions appeared piecemeal, lacking the clarity and breadth of earlier developments, and the city was in danger of becoming a bland amalgam.

Our response was that CMK's originality already makes it distinctive and that, as it grows, it should stay in touch with what makes it special and different. Our conception of

public art ceased to be about pieces of art inserted into the public realm and started to be about using artistic thinking to re-connect with the city's original artistic vision. Our (breezy!) manifesto for CMK became: "Milton Keynes must again apply artistic thinking to its totality, not just its details. Artistic thinking could be the motor that creates distinctiveness and steers the future development of the city."

We went on to articulate an idea for what public art could be for CMK. We began by widening the scope for artistic thinking by addressing the question of scale. We argued that public art is often commissioned as a way of trying to solve specific problems of a site—the site is boring, for example, or out-dated or prone to vandalism—and because it must solve these problems, the process of creating an artistic outcome in this context is in fact a process of design. If public art is actually design, and a prerequisite of design is that it considers the environment at every scale, why can't public art be made to relate to every scale—urban planning, public space, architecture, landscape, transport, land use planning, economic development? This kind of thinking across different scales is particularly relevant in CMK, which is the outcome of a consistent and singular artistic vision operating at all scales from its layout to its details. This meant that, for CMK, public art could mean *artistic thinking applied to the whole environment*.

For example, applying artistic thinking at the macro-scale level of city planning could mean arguing to maintain the city's rectilinear plan, an important feature of its distinctiveness; where sub-division is called for, the grid should be broken down into smaller square blocks, rather than 'organic' curvy units, as was being proposed, and the buildings designed to emphasise and reinforce the corners of those blocks. On the smaller scale, we argued that the city's piecemeal introduction of new and assorted street furniture, however individually fascinating and unique, is compromising the city's originality and making it less distinctive. The *portes coucheres*, granite landscape details and square black kick-rails, cohesively and comprehensively applied to the entire city, are the environmental heritage of CMK; artistic thinking here could be about re-asserting the validity of this artistic vision.

We identified ways to experiment with the format of projects to encourage different kinds of creativity. We proposed, for example, that commissions for public works be open to any discipline, or different combinations of disciplines—art, landscape, surveying, design, dance, music, architecture, drama, planning or anything else. We suggested that, instead of the cliché one-off signature piece, an idea could be repeated across the city, and have as much impact as a single big idea, or layered over different timescales, temporary and cumulative projects as well as permanent ones. We also argued that interventions need not be instantly recognisable as public art, but that there can be an enjoyable ambiguity about whether something is art or architecture or landscape or design—or something else.

As the creativity of any project is delineated by the creativity of its brief, we argued for developing briefs for public works as creative ideas in their own right, for example, by specifying unusual stipulations such as requiring all new buildings to incorporate *portes cochère* to encourage interesting responses. We suggested that proposals for generic interventions, such as new paving or lighting, should be for the whole or a significant area of CMK rather than a small part of it, to prevent the city becoming bland and fragmented; proposals for repeated elements, such as bus stops or litter bins, should only proceed if there are no existing designs in use across the city or a decision is made to replace all current items, to build on CMK's heritage of consistent detailing; and finally, that briefs for proposals to develop sites of a similar type, such as roundabouts, should address all those sites, not to make them identical but to ensure a consistency of approach that contributes to the wholeness of CMK and its distinctive identity.

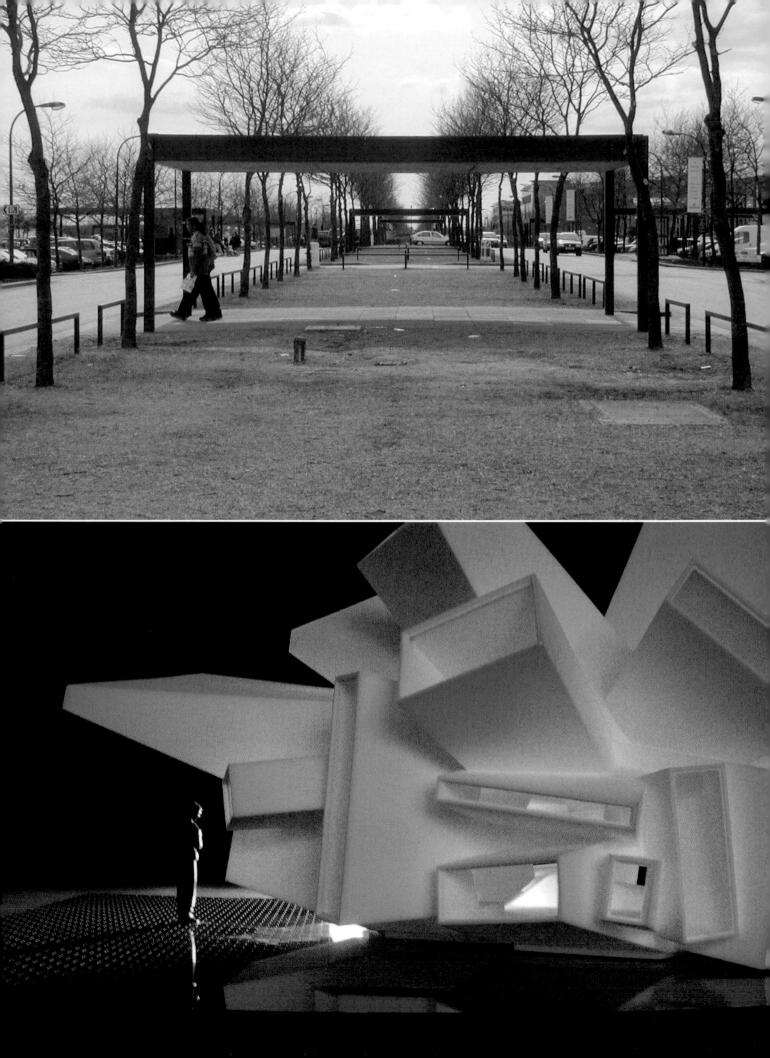

1 Habitat's appointment of Tom
Dixon in 1988 as head of design
revived the flagging home
furnishings store. Dixon designs for
Habitat, leads its artistic direction
and commissions new design for
the company.

Artist Tom de Paor acted as Lead
Artist for a programme of works by
a variety of artists along the A13
road in Barking and Dagenham,
London in the 1990s. The scheme
took advantage of programmed
roadworks to implement artistic
schemes, including landscape
design, light works, new sculptural
commissions and community
projects. De Paor's role was to give
vision and direction to the project
as well as contributing his own
artwork.

Our main proposal was that CMK establish a new role within the city, that of Lead Artist, not an artist in residence but a new idea of a creative thinker who would work within the city's development framework to revive its tradition for broad thinking, creating an artistic framework for future development that would make CMK more complete, not diluted and similar to other places. The Lead Artist would be strategically engaged with the structure and machinery of the city's development processes and work alongside key agencies, governance, developers, organisations and individuals; and play a guiding role in drawing up briefs for projects in the city, carrying out pilot projects and drawing in other practitioners. This role, to our knowledge, was unprecedented, but we cited as models the roles taken by Tom Dixon at Habitat and Tom De Paor on the A13 Artscape project; we pointed out how the lack of any such strategic artistic direction had been so detrimental at the Millennium Dome.[1]

We did not argue for artists for artists' sake and, critically, pointed out that the Lead Artist could come from any discipline. However, passion for the uniqueness of CMK would be prerequisite, as well as being able to work within its political and cultural environment. Above all, the Lead Artist would require the ability to think creatively about the totality of CMK, now and in the future, the critical point being the quality and scale of their thinking, not the discipline they come from.

True to its tradition for innovative thinking, the city went for this new idea and appointed Thomas Heatherwick Studio, a design practice, as Lead Artist for Central Milton Keynes. There have been many discussions since, a lot of briefing papers, meeting minutes, committee notes and design proposals—and nothing on the ground. This is not unexpected: we recognise that ideas which see the light of day as finished projects always have to navigate a long and circuitous journey to the surface.

For our practice, the rewarding part of the process was the thinking that went into the initial consultancy phase, having the opportunity to scrutinise such an extraordinary city and examine the particular nature of that city's creativity. Asking what 'art' might mean to that city helped us clarify our perspectives and articulate our own relationships, as non-artists, to that word.

Thomas Heatherwick Studio,
lit model of Info Box, a
proposal for a public-access
information point to inform the
public about changes afoot in
the city

Thomas Heatherwick Studio, *Sitooterie*, 2003, Barnard's Farm, Essex

Thomas Heatherwick Studio, design for Japanese temple, 2005, Kagoshima, Japan

Thomas Heatherwick Studio,
*Rolling Bridge*, 2004, (left to
right) closed, in the process of
closing and open, Paddington
Basin, London

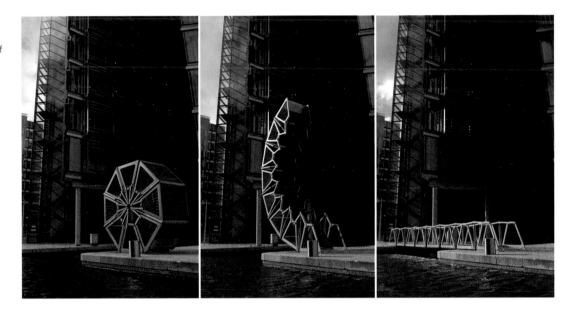

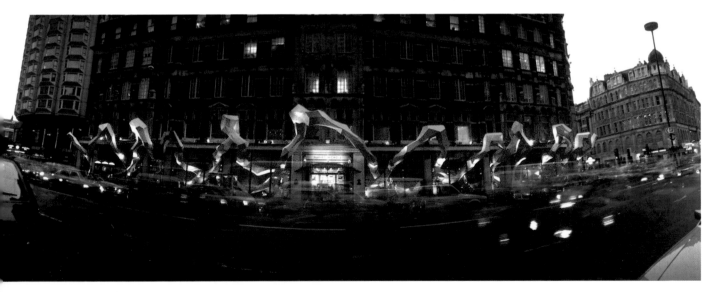

Thomas Heatherwick Studio,
*Autumn Intrusion*, 1997,
temporary installation at
Harvey Nichols department
store, London

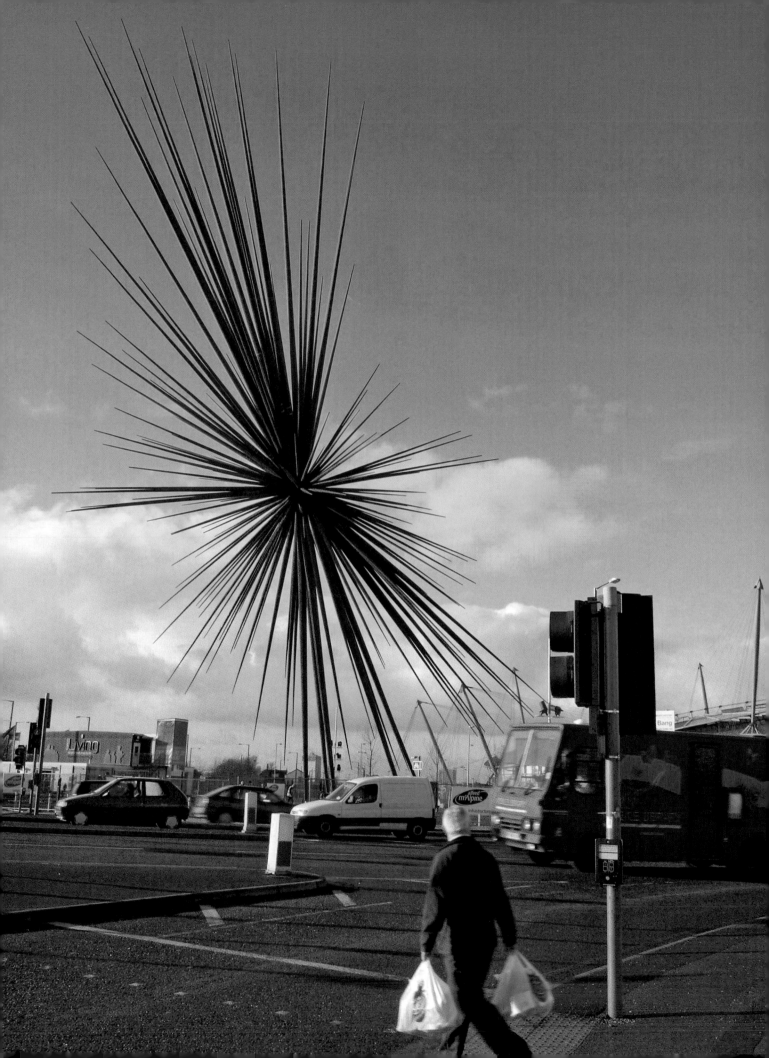

# The Artist as Place Maker
## Chris Murray

The role of art and artists in the development of buildings and public spaces has a long and controversial history. Described today as public art, this intensely politicised field provokes deep feelings. This essay briefly explores the potential contribution of artists and an artistic approach to place making in the twenty-first century, a period of massive urban renewal and expansion in England, and suggests how this could be supported.

Artists have often played a more fundamental role in creating places than by simply creating art. In the last century the revolutionary approach of the Bauhaus redefined the relationship between the work of artists and the design of buildings, interior furniture and fittings. Founded in 1919 from the amalgamation of Henry van der Velde's School of Applied Art and the Academy of Fine Arts, the Bauhaus reflected a new, integrated approach to the teaching of art, craft and architecture in order to educate creative people capable of large-scale collaborative projects or the 'Gesamtkunstwerke', the total work of art.

Walter Gropius, founder and first director of the Bauhaus, summed up the ethos of the school in the Bauhaus Manifesto of 1914:

> There is no essential difference between the artist and craftsman: the artist is a craftsman raised to a higher power.... Let us create a new guild of craftsmen, without the class-snobbery that tries to erect a haughty barrier between artist and craftsman. Let us conceive, consider and create together the new building of the future that will bring all into one single integrated creation: architecture, painting and sculpture rising to Heaven out of the hands of a million craftsmen, the crystal symbol of the new faith of the future.

With an energetic mix of vision and practicality, the Bauhaus united the teaching of fine art, applied art and architecture, producing design ideas so powerful they continue to look fresh and futuristic 80 years on. Bauhaus furniture and building designs were so forward thinking that it has taken consumer taste almost a century to catch up with them.

In recent years artists have extended their role beyond architectural collaboration and design to an involvement in the creation of places and spaces. They are not just making art within public spaces, but also acting as 'place makers', and contributing to the whole development process.

Artists and designers by their nature and, importantly, their training, are inquisitive, experimental and challenging of received wisdom. These qualities are essential in finding new ways of place making. But to date few have managed to cross the divide into the world of urban development. One designer who has successfully taken up the challenge and pushed thinking forward in this arena is Thomas Heatherwick.

I first met Thomas when he was working on the masterplan for Milton Keynes' city centre, a bold vision that we both hope will become reality. Thomas's role was not to make artwork, or necessarily to design objects, but to encourage a new perspective amongst public and professionals about their city centre and how it could change. His practice does

Thomas Heatherwick Studio, *The B of the Bang*, 2005, City of Manchester Stadium

not just help people to think differently, it does things differently, from developing and engineering a 30 storey residential tower in London, to working on prefabricated housing, to redesigning retail spaces in New York.

Thomas is not just a believer in collaboration, he knows it is the only way to succeed. He has detailed and considered views on this topic, but during our interview for this essay, he made two fundamental points. Firstly, that design and construction have become badly detached which inevitably leads to poor development. Secondly, that artists—or, as Thomas believes, 'artistic thinkers' from any discipline—have something unique to contribute to place making, not as an adjunct to development, but by leading development in a new direction.

> I believe that there has been a huge disconnect between the designers and the makers of buildings. It's not just that designers are not understood or not used properly, it's also that people on the ground, responsible for putting ideas into action, are not nurtured. Everyone needs to be involved and excited by the making of new buildings and spaces. For example, we've recently been working with an asphalting company and had some exciting conversations about new and different ways to use the skills and materials of this ordinary everyday process.

Thomas Heatherwick Studio, *Blue Carpet*, night shot, 2001, Newcastle upon Tyne

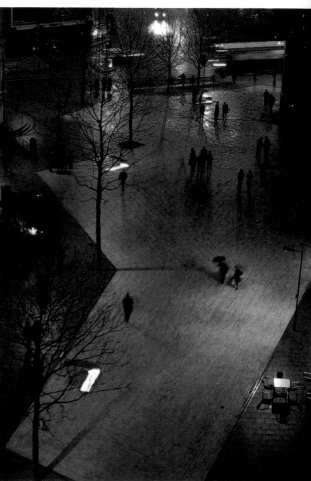

An artist's role in place making may not be to take the lead as brilliantly inspiring individual, but to encourage creative and experimental approaches to team work. Unearthing new practice and bringing it to the attention of professionals working in the field of regeneration and development is essential; equally important is the way we collectively learn about what makes good buildings and places. For a long time we have been encouraged to fundamentally rethink the way we train people involved in making places. This has been reflected in the work of Constructing Excellence, the Sector Skills Councils, the Construction Industry Training Council and the Commission for Architecture and the Built Environment (CABE), to name but a few.[1] However, even after years of evidence and encouragement to the contrary, learning largely continues to take place in silos.

Having originally trained as an artist myself, I believe that the learning experience offered by the arts and art colleges has something to offer other disciplines. Art and design training encourages experimentation and generalisation for one or two years before specialising. There is a strong emphasis on creative problem solving and on what Franco Bianchini has described as a 'Cultural Planning' approach that is:

- holistic, interdisciplinary, intercultural and lateral;
- innovation oriented, original and experimental;
- critical, inquiring, challenging and questioning;
- people centred, humanistic and non-deterministic;
- 'cultured' and informed by a critical knowledge of cultural forms of expression.[2]

The training of artists and other professions that contribute to creating successful environments—economists, social and community workers, justice workers—does not

1 See www.constructingexcellence.org.uk; www.ssda.org.uk; www.citcwa.com; www.cabe.org.uk

2 Bianchini, Franco, "The relationship between cultural resources and tourism policies for cities and regions", *Planning Cultural Tourism in Europe*, D Dodd and A van Hemel eds., Amsterdam: Boekman Foundation, 1999, pp. 78-90.

usually take them anywhere near construction workers, planners or architects, and it should. A closer cooperation and understanding between disciplines involved in making places at the very earliest stages of learning is essential to 'roping back together' design and construction and ensuring it is fit for purpose. We need to go back to the drawing board, rethink our training methods and the principles underlying them, and work across professional boundaries—artists and planners taking a common module, architects working on building sites as labourers, engineers working with three dimensional designers, or any other combination that shakes us out of our individual trees and gets us collaborating properly. A greater understanding of each other's territory could also avoid some of the terrible culture of blame that afflicts us. In our increasingly litigious society, it is no longer a paradoxical urban myth that some local authorities have a larger budget for claims arising from accidents in their streets than they do for maintaining those streets.

Better design is not just about aesthetics, it's primarily about making buildings and spaces that work properly. Oscar Wilde put it something like this: "Most of the ugly things in this world have been made by someone trying to make something beautiful, and most of the beautiful things by someone trying to make something that worked."

Whilst form often follows function, the benefits of better design are not always obvious and can actually be a matter of life and death. John Urry, in *Re-imagining East Lancashire*, outlines the grim reality of not investing in places.[3] In the Chicago heat wave of 1995, mortality was much higher in disadvantaged areas. Urry puts this down to the difference between neighbourhoods that afforded or impeded social interaction.

> This was not just a question of housing but of the connectedness of housing with habitable streets, with accessible parks, shops, cafes, neighbours and so on. It was a question of people's everyday mobilities. Where these were rich and diverse, people were much more likely to survive the heat wave, where people were not able to get out and about, they died in large numbers.

3 Urry, John, *Re-imagining East Lancashire*, London: CABE, 2004, p. 6.

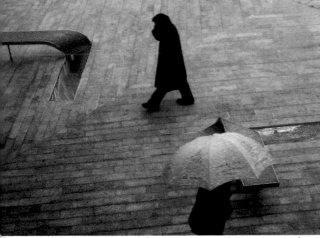

Thomas Heatherwick Studio, *Blue Carpet* (detail), 2001, Newcastle upon Tyne

Thomas Heatherwick Studio, design scheme for approaches to Guy's and St Thomas's Hospital, 2005, London

Creating better neighbourhoods is not, and never will be, the exclusive prerogative of any one profession or sector; better place making needs professionals to cooperate across disciplines and divides. Is there a role for artists in bringing about better development? Thomas signposts the relationship between process and outcome as key:

> Seeing construction in action is thrilling... to get a building to happen at all is a minor miracle; to get it to happen well is much more difficult.... There's so much conspiring against quality in built development. First, we should look at some successful outcomes, some good projects, and then investigate the process that led to them taking shape; what was different? I don't think it should be the other way round; we could be endlessly inventing new processes that don't make things better. Through my work I've become very interested in procurement. I think that navigating the procurement and development process successfully is actually a kind of artistic project in itself.

Creating a stronger pool of professional skills—the supply—is essential to successful placemaking, but without the corresponding demand for those skills, the results are doomed to failure. Having a client that understands what they want and how to get it, is essential to good development. The importance of this is now recognised by the British Government, which, through CABE, is working with politicians and planners at a local level to improve skills and understanding of the design, development and procurement processes and raise aspirations for high quality architecture and public space.

Thomas describes the need for artists to walk the walk.

> There's a lot of money tied up in development. It's a serious business. Artists involved in this need to marry creating something special to the ability to take responsibility. You have to show you can do that. My studio isn't there to compete with what's already happening, with what's on the market, we're only interested in exploring new and different ways of working that lead to better outcomes. I think that artists can provide the 'lead direction', rather than being additional to that direction; I think it's a mistake to identify artists as 'non-architects'.

This is increasingly the direction of Thomas Heatherwick Studio, exemplified in a current project to re-configure all the approaches to Guy's and St Thomas's Hospital in London, where the team are undertaking the whole project, from re-directing traffic flows and reconfiguring the car parking arrangements, to rebuilding the boiler house and designing a new shop. Other artists are already playing central roles in large-scale development. Bruce McLean's successful collaboration with architect Irena Bauman on the Bridlington Seafront development has created a distinctive and popular holiday destination which has won many

Gordon Young and Why Not Associates, *Eric Morecambe Memorial*, 1999, Morecambe seafront

awards. Gordon Young's work as Lead Artist at Morecambe, where he was the driving force in redesigning the waterfront, has revitalised the tourism industry in the area, and has led to his central role in rethinking Blackpool, working as an equal partner with a team of artists and urban designers, with a remit to think out of the box and avoid the tried and tested. It will be difficult for a lot of developers to imagine how an artist could lead such a scheme, but at a time of intense growth in construction and regeneration in England, where innovation, experimentation and creativity is vital, this could, and should, become a reality.

The Bauhaus focused on an integrated approach to the development of buildings, using the Gothic cathedral as an emblem for the 'total work of art', and some of their work started to address the integration of buildings with landscaping. However, without the benefit of a real understanding of the socio-economic factors that influence the development of place, many of the proposals from Bauhaus architects and their contemporaries—from le Corbusier's *Ville Contemporaine* to Antonio Sant'Elia's *Città Nuova*—were utopian visions without real thought for the daily lives of individuals. Perhaps this is unsurprising; the Bauhaus was a product of its time—a radical, idealistic and ideologically driven phenomena. Paying proper attention to the full complexity of context is a starting point that has often been ignored, creating potential urban nightmares.

Coping with the level of new development and regeneration in England is hard enough; ensuring quality and innovation will require persistence, vigilance and a strong emphasis on new ways of learning and working across disciplines. Perhaps what's needed now is a kind of Bauhaus for place making, a new approach to learning which is truly interdisciplinary, that brings together the key sectors involved in regeneration and new development (built environment, economic, social, cultural and community) creating a more rounded and able professional. This is close to what has been called for by Sir John Egan and his Task Force in the Academy for Sustainable Communities, a new learning initiative funded by the Office of the Deputy Prime Minister.[4] Its role will be to draw attention to an increasing skills deficit amongst those charged with creating and renewing places and communities; to help us understand more about what makes successful places; and to increase the quality and amount of learning on offer to support imaginative place making.

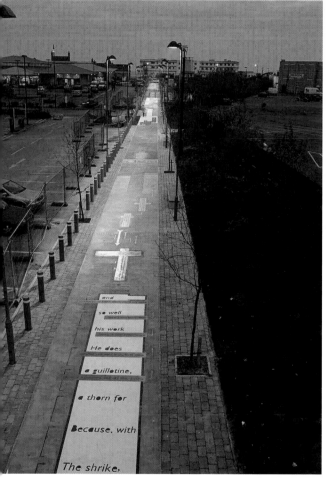

Gordon Young and Why Not Associates, *A Flock of Words*, 1999, Morecambe seafront

4 The Construction Task Force's report to the Deputy Prime Minister John Prescott, *Rethinking Construction*, 1998, on the scope for improving the quality and efficiency of UK construction. See www.dti.gov.uk

In moving forward, it is imperative that the role of creativity, and of artists, in place making is given full consideration if we are to make places where people with a choice want to live. Artists and designers do not have a monopoly on creativity though; it can be found and instilled within many different occupations. It is also a myth that risk and an abandonment of the rules are central to innovation; Japanese management systems are incredibly innovative, but not necessarily risky, nor do they exist outside a well defined set of rules of engagement. What I believe to be certain is that creativity and innovation are vital to the urban growth and renewal taking place in this or any other country. Artists and designers not only have a core contribution to make to the creation of places, but their understanding of the creative process and their ability to think outside the box and to encourage others to do so, is vital to improving our working practice, leading to higher quality outcomes that are fit for purpose and truly sustainable.

# Thomas Heatherwick

*B of the Bang Conical Geometry*, 2004, limited edition artist's print

# Project Details

**Simon Read**
**Thames Path Research Residency**
1993–4

Simon Read was one of three artists invited by the Countryside Commission to undertake research residencies along the Thames Path, over the period 1993-6.

The Thames Path is a 290 kilometre walking route, which follows the old riverside towpath for much of its length from its Cotswold source to the Thames Barrier in London. The residencies aimed to find new ways to interpret and communicate historical, cultural, anthropological, geological, sociological, industrial and environmental aspects of the river. Each artist was allocated a section of the river to explore and invited to research and realise new work which challenged traditional and familiar perceptions of the River Thames.

Simon produced a series of drawings and photographs, which were exhibited in London and his residency led to a commission to create a permanent wall drawing at the Thames Barrier. His work, together with work resulting from the other two residencies (by Julia Manheim and John Frankland), including sketchbooks, written descriptions, photographs and artists' books, now forms part of a creative archive housed at the River and Rowing Museum, Henley.

The Thames Path Public Art Project was initiated by the Countryside Agency and supported by Allied Domecq and Southern Arts. A second programme of artists' residencies relating to the tidal Thames was developed and managed by Public Art Development Trust (PADT).

**John Kippin**
**Photography Residency,**
**Greenham Common** 1998–2001

From 1983-91 Greenham Common was a US airbase housing 96 ground launch cruise missiles. In 1997 West Berkshire Council acquired the Common from the Ministry of Defence and embarked on a major programme of work to reclaim the area for recreation and wildlife conservation. Greenham Common is now a designated SSSI—a Site of Special Scientific Interest.

In 1998, photographer John Kippin was commissioned to undertake a year long residency on the Common. The aim of the residency was for the artist to document the transformation of the site from US airbase to publicly accessible lowland heath, and to develop a new body of his own work in response to the Common. Work resulting from the residency was shown in the exhibition *SSSI Greenham Common* at the Imperial War Museum and on Greenham Common in 2001, and at Side Gallery, Newcastle in 2004. A book of John's work from the residency, *Cold War Pastoral*, was published by Black Dog Publishing in 2001.

John Kippin's residency was commissioned and funded by West Berkshire Council. The exhibition of his work was developed in partnership with the Imperial War Museum and supported by the Arts Council of England (National Touring Programme).

**Peter Randall-Page**
**Commission for Newbury Lock** 2000–3

Sculptor Peter Randall-Page was one of three artists selected by Newbury Town Council to create proposals for an artwork for Newbury Lock, a site of local historical significance. His designs were selected for development and his sculpture, *Ebb and Flow*, launched the Newbury Town Trail, a series of artworks under the theme of *Flow*.

*Ebb and Flow* comprises an enormous silver-grey granite bowl, nearly two and a half metres in diameter and weighing eight tonnes, set at the centre of a spiral granite path leading down from the lock. The bowl is connected to the lock by underground piping which activates the sculpture by natural water pressure. When the lock fills, water flows into the bowl and as the level of the lock water goes down, it empties away.

The granite for the bowl was quarried and turned in Germany, and carved by the artist in Devon. Its interior patterning of opposing spirals controls the water as it rises and falls.

An extensive education project ran in parallel to the development of *Ebb and Flow*, involving 300 pupils from six local schools.

*Ebb and Flow* was commissioned by Newbury Town Council and developed in partnership with British Waterways, Kennet & Avon Canal Trust, Newbury Society, New Greenham Arts, West Berkshire Council, Newbury Town Centre Management, and Newbury Open Studios. The project was funded by Arts Council England, WREN, Vodafone, The Colefax Trust, The Foundation for Sports & Arts, the Esmée Fairbairn Foundation, West Berkshire Council, West Berkshire Education Business Partnership, The Headley Trust, Newbury Building Society, and King Lifting Ltd.

**Louise Short**
**Schools Residency, Riverside Walk, Aylesbury** 2000

Riverside Walk is a linear park which runs along the floodplain of the River Thames. It is one of the few extensive green spaces in Aylesbury open to the public, but has not been well used by the local community.

In 2000, Louise Short was appointed by Aylesbury Vale Council to work in residence at three schools local to the park—Meadowcroft Junior School, Meadowcroft Infants School and Quarrendon Upper School. Her brief was to develop a series of creative workshops with pupils which would encourage them to explore the plants and wildlife on Riverside Walk, and to create a temporary artwork for the park. The aim of the project was to develop the individual creativity of the pupils and promote greater understanding of the artistic process, as well as create a sense of community ownership of the park and raise its profile in the town.

Louise developed a series of creative workshops with the schools which resulted in an exhibition of the pupils' work, and the showing of a temporary projected artwork, *Mothshadowmovie*, created with participation of the pupils. She also created a report for teachers outlining the methodologies she used, providing a template for further workshops.

Louise's residency and *Mothshadowmovie* were commissioned and funded by Aylesbury Vale District Council. The exhibition of pupils' work was developed in partnership with the British Trust for Conservation Volunteers.

**Peter Freeman**
**Commission for Winchester City Centre** 2003

*Luminous Motion*, Peter Freeman's interactive light column for the grounds of Winchester Cathedral, is one of the first artworks in the country that relies on mobile telephones to influence its appearance. A tall column of stainless steel, pierced by small fibre-optic lights, the sculpture changes colour or pattern according to different text messages sent by members of the public.

Peter's brief was to develop a light art project that celebrated Winchester and reflected routes and pathways through the city. The idea for *Luminous Motion* developed from a series of research visits, where he was impressed with the idea of Winchester as a city situated at the convergence of pathways, and its rich history as a centre for spiritual and political power, as well as the suggestion that Winchester's future lay in making it a centre for virtual communications. *Luminous Motion* is sited in one of the spiritual centres of Winchester, the Cathedral grounds.

*Luminous Motion* was part of the Winchester Light Art Project, a series of three light based commissions for Winchester. Previous commissions included new work by artists Ron Haselden (*Colour Swatch*) and Pierre Vivant (*alfreds.net*).

*Luminous Motion* was commissioned by Winchester City Council and developed in partnership with Hampshire County Council, the Chapter of Winchester Cathedral, and The Winchester Gallery. It was funded by the National Lottery through the Arts Council of England and Winchester City Council.

**Sasha Ward**
**Commission for The Great Western Hospital, Swindon** 2000–2

The Great Western Hospital opened in Swindon in 2002. As part of its development, Swindon & Marlborough NHS Trust developed *Artalive*, a programme of high quality, professional arts activity integral to the new hospital environment, including commissions, a temporary gallery space and loaned artwork.

Sasha Ward's brief was to create one of the first site-specific commissions, an artwork for the new multi-faith Chaplaincy Centre. To research the work, she consulted with a range of multi-denominational and secular groups to ensure that her final designs were appropriate to the whole community. The five metre square, richly coloured glass screen she created for the space is designed to capture natural daylight entering through two small windows, to produce a peaceful light effect within the Chaplaincy. The individual panels of the screen were hand painted and crafted by the artist, who also developed a lighting scheme for the space, designed to balance the effects of natural light.

Sasha Ward's glass screen was commissioned by The Swindon & Marlborough NHS Trust and supported by The Swindon & Marlborough NHS Charitable Fund, The Regional Arts Lottery Programme, The Underwood Trust and The Jerusalem Trust.

**Simon Patterson**
**Commission for The Open University,**
**Milton Keynes** 2003–5

In 2003 the Open University appointed Simon Patterson to work 'in residence' with its Chemistry and Planetary Sciences Departments, and create an artwork for their new building designed by architects Ridge & Partners.

Simon's brief was to celebrate the scientists' ground-breaking work and create a site specific artwork responding to the spaces and functions of the new building. As part of the initial residency phase, he developed a dialogue with the planetary scientists and chemists to better understand their current research programmes and the way they planned to use the building.

The artwork he developed from his research, entitled *Gort, Klaatu barada nikto*, is based on pulsars (dense stars). It consists of an avenue—or 'runway'—of light and sound that leads up to, and into, the entrance to the new building. The work acts as a welcome to the building as well as referencing the exchange of information between the university departments and space, setting up a 'conversation' between real and artificial pulsars.

Simon Patterson's work was commissioned by the Open University and developed in partnership with Milton Keynes Gallery and Ridge & Partners.

**Jacqui Poncelet**
**Consultant Artist, Didcot Arts Centre**
2001–7

A new arts centre, funded by South Oxfordshire District Council, is currently being built in Didcot, due to open 2007. The Centre will comprise a performance space, a visual arts workshop and multimedia suite and exhibition space. Since the earliest design stages, two artists, Jacqui Poncelet and Richard Layzell, have been working with the architects Ellis Williams on the development of designs for the building.

Jacqui Poncelet's role as Consultant Artist has been to work as a member of EWA's design team, led by Dominic Williams, contributing to the overall architectural design development, and developing proposals for her own work as part of the building fabric.

The building has gone through a number of redesigns since 2001, and Jacqui's ideas have had to be fluid to respond to these changes. Her early design ideas included seating integrated into exterior cladding, the application of coloured anodised aluminium on the facade, and a series of mirrored and etched windows. Jacqui is currently working with EWA on proposals for interior acoustic panels and shaped cladding panels, which will create texture and shadow on the exterior of the building. She is also working with the architects to incorporate design ideas developed by Richard Layzell, Resident Artist, who has developed a series of community related commissions for the building.

Jacqui's consultancy and design work has been commissioned by South Oxfordshire District Council with support from the Royal Society of Arts' Art for Architecture scheme and Arts Council England, South East.

**Alison Turnbull**
**Commission for Milton Keynes Theatre**
1996–9

As part of the development of the new Theatre and Gallery for Milton Keynes, a proportion of the capital budget was set aside for artist involvement in the new buildings. In 1996, when detailed designs were being developed, Milton Keynes Council appointed Edward Allington as Principal Consulting Artist, with a brief to work in close collaboration with the architects Blonski/Heard, to create a programme of site related commissions.

Edward Allington's proposal was to focus the commissioning programme on a collection of wall-based artworks. Alison Turnbull was one of five artists (with Estelle Thompson, Lily van der Stokker, Michael Craig-Martin and Edward Allington) who were invited to create wall drawings for the Theatre. The artists were invited to Milton Keynes, introduced to the project through a series of workshops, and asked to select a site where they wished to work, in either front or backstage areas of the venue.

Alison Turnbull's work, *Moon*, is drawn in graphite and ink directly on to the bare concrete of the foyer wall, and can be viewed both from within and outside the building. Her monumental work, measuring four metres in diameter, is based on a nineteenth century topographical map of the moon. Like the moon, Turnbull's work is illuminated at night when the foyer lights come on.

Other commissions included a stainless steel theatre curtain by Janet Stoyel; a reception desk, shelving and seating by Rupert Williamson for Milton Keynes Gallery; and a large-scale temporary video projection for the Theatre flytower by Bruce McLean & David Proud to celebrate the opening of the new venues.

## Thomas Heatherwick
### Lead Artist for Central Milton Keynes
2001–

The programme of artworks for Milton Keynes Theatre and Gallery was commissioned by Milton Keynes Council, and developed in partnership with Blonski/Heard architects and Milton Keynes Theatre & Gallery Company. It was funded by The Arts Council of England (National Lottery Capital Award), English Partnerships and Milton Keynes Council.

In 2001, designer Thomas Heatherwick was appointed by Milton Keynes Council as consultant artist to work with EDAW, urban design consultants, on the new Development Framework for Central Milton Keynes (CMK), a new plan for the future development of the city centre. He contributed to the document as a whole and also wrote an appendix paper, "Public Art in Central Milton Keynes", which advocated for an innovative and holistic approach to the city centre, and the application of 'artistic thinking' to all aspects of its future development. His paper outlined a range of specific proposals, including artist involvement in the design of landmark car parks, a micro museum integrated into public space, and artist collaboration in the design of transport systems.

In 2002 Thomas was appointed Lead Artist for CMK. His brief was to take forward the recommendations of "Public Art in Central Milton Keynes" through continued consultancy work and to develop designs for a prominent space or spaces in CMK.

His consultancy work led to collaboration with Artpoint on "A Public Art Plan for CMK 2004-2014", a £3.2 million plan for public art funded mainly through developer contributions. His design work included a proposal for a mobile 'information box' for CMK. The 'Info Box' is intended as an extraordinary structure which will house information on Milton Keynes, past, present and future. It is designed to raise the profile of the city to local, regional and national audiences and provide a focus for public engagement with city centre development and city expansion.

Thomas Heatherwick's work has been commissioned by Milton Keynes Council in partnership with English Partnerships, and has been supported by Southern Arts and the Regional Arts Lottery Programme.

# Commentators' Biographies

**Louise O'Reilly** is a visual art project manager and consultant with over ten years experience of working with artists in the public realm. Following a foundation year at Central St Martins School of Art, 1985, she gained a law degree at the London School of Economics, 1989, a Post Graduate Diploma in History of Art and Design at Winchester School of Art, 1993 and an MA in History of Art at Birkbeck College, University of London, 2003.

Louise O'Reilly worked for the Hampshire Sculpture Trust and Southern Arts Board before joining Artpoint in 1994, taking up the post of Director in 2005. She has worked extensively on artists' commissions within the built environment. She is motivated by a desire to create meaningful exchanges between contemporary visual arts practice and everyday life.

**Edward Allington** studied at Lancaster College of Art, Central School of Art, and the Royal College of Art. He was Gregory Fellow at Leeds University 1990-3, and Sergeant Fellow at the British School at Rome in 1996, and has undertaken artists' residencies in France, Ireland and the UK.

Usually identified with the British object sculptors of the 1980s, he has exhibited in museums and art galleries throughout the world, has completed major public commissions in the UK, Germany and France, and is represented in major public and corporate collections in the UK, Europe, Japan and the USA. He has written for various art magazines, is a regular contributor to *Frieze*, and in 1998 published a collection of essays *A Method for Sorting Cows*. He lives and works in London and is currently Head of Graduate Sculpture at the Slade School of Fine Art.

**Stephen Turner** is an artist who has employed natural processes and materials to look at ideas about the cultural landscape. His recent projects include *Cella*, an installation for Turner Contemporary in Margate; *Tree Rings* for Stour Valley Arts; and *Four Shores*, a public art project for the Medway Swale Estuary Partnership.

Stephen Turner will spend the summer of 2005 alone on the derelict Red Sands Fort, a concrete platform 13 kilometres off the north Kent coast, where he will explore the concept of creative solitude.

**Ian Walker** is Programme Leader for the MA Documentary Photography at the University of Wales, Newport. He has written extensively on photography, including the book *City Gorged with Dreams: Surrealism and Documentary Photography in Interwar Paris*, Manchester University Press, 2002. He is presently working on a second book on Englishness, Surrealism and photography.

Ian Walker has also exhibited his own work nationally and internationally, most recently at the Freud Museum, London and the Byzantine Museum, Thessaloniki, Greece.

**Roger Deakin** is a writer and broadcaster with a special interest in nature and the environment. He studied English at Peterhouse, Cambridge, and is a founder-director of the arts/environment organisation Common Ground (www.commonground.org.uk).

Roger Deakin is the author of *Waterlog. A Swimmer's Journey through Britain*, Chatto & Windus and is currently working on *Touching Wood*, a new book about a wildwood journey to be published by Hamish Hamilton in 2006. He lives and works in Suffolk.

**Richard Layzell** is an artist, performer and 'visionaire', whose work in industry and the arts has been acknowledged internationally. His quest for new contexts for his work has led to solo and collaborative projects with numerous institutions and organizations, both public and private, and involved people of all ages and abilities worldwide.

His interactive installation *Tap Ruffle and Shave* was seen by 100,000 people in four major UK cities. His work is included in The Gallery of Modern Art, Glasgow; the Science Museum, London; The London School of Hygiene and Tropical Medicine; and Skills for People, Newcastle. He is the author of *The Artists Directory, Live Art in Schools* and *Enhanced Performance*, and is one of six artist/researchers with ResCen at Middlesex University.

**John Gillett** is Director of The Winchester Gallery at Winchester School of Art, University of Southampton. As a digital media artist he was artist in residence at ArtSway in 2001-2, leading to a solo exhibition, *Loss of Gravity*, at Artsway, 2002, and *John Bull War and Peace* at the Bracknell Gallery, South Hill Park, 2004.

John Gillett has written extensively on contemporary visual art. His contributions on public art include *Pierre Vivant: Les Caractères de la Verrière*, SAN de Saint Quentin en Yvelines and Ville de la Verrière, 1998, and *Public:Art:Space.10 years of PACA*, Merrell Holberton, 1998. He is currently one of a number of artists commissioned to make proposals for the refurbishment of Slough High Street under the Art at the Centre scheme.

Hugh Adams has published extensively on visual arts and cultural issues and is particularly interested in the professional situation of artists. He is Chair of Cywaith Cymru/Artworks Wales, one of the largest public art and artists' residencies organisations in Europe.

Hugh Adams is a member of the Wales Venice Biennale Steering Committee and the Art and Crafts Commissioning body for Richard Rogers' Welsh National Assembly building. He is director of The Art Agency, based in Bristol, which is concerned with visual arts research and commissioning.

Siân Ede is Arts Director for the UK Branch of the Calouste Gulbenkian Foundation. She frequently writes, speaks and chairs discussions on Art and Science in Britain and internationally. Formerly Drama Officer at the Arts Council of England, she also taught the post-graduate Arts and Education programme at City University.

Siân Ede is editor and co-author of the book *Strange and Charmed: science and the contemporary visual arts*, Gulbenkian, 2000. Her new book *Art and Science* will be published by I B Tauris in 2005.

Dominic Williams was born in Manchester in 1965. After a brief spell at art college, he graduated from Sheffield Architectural School in the late 1980s with a B.Arch (Hons), Dip.Arch (Dis) and is a member of RIBA. Past projects have included a virtual mausoleum and a Franciscan retreat building. His first major completed work was the Baltic Centre for Contemporary Art, Gateshead which attracted over a million visitors in its opening year 2002, and also won a RIBA, Blueprint and Civic Trust award. Alongside Didcot Art Centre, he is currently working on the Oriel Mostyn Gallery, Wales and a new studio converted from a church in central Manchester. He is a Director at Ellis Williams Architects and a visiting critic at a number of Universities.

Michael Stanley joined Milton Keynes Gallery as Director in July 2004, following four years as Curator at Ikon Gallery, Birmingham, where he was responsible for the Turner Prize nominated exhibition of Anya Gallaccio's work, as well as the critically acclaimed exhibition *What I Did this Summer* by George Shaw. He previously worked as Curator of Art at Compton Verney, 2000-2 where he took the lead curatorial role in developing a series of major projects and the capital development of the gallery, which opened in 2004.

Michael Stanley has created collaborative projects with international venues and artists, including, most recently, MUDAM, Luxembourg and Birmingham Museum of Art, Alabama. He also founded an independent commissioning organisation called epilogue, 1997–2001, where he curated non-gallery exhibitions such as *Tabley*, 2000. He received a First Class Honours degree from the Ruskin School of Drawing and Fine Art, Oxford University, 1992-5.

Chris Murray originally trained in art and design, and worked in schools, colleges and health settings. Joining Milton Keynes Council in 1997, he went on to lead the UK's first local authority Cultural Planning Unit, combining economic, cultural and some regeneration services. He is the author of *Making Sense of Place: new approaches to place marketing*, Comedia and De Montfort University, 2001, and has worked as consultant on a number of regeneration and urban renewal projects.

In 2002 Chris Murray was appointed Director of Learning and Development at the Commission for Architecture and the Built Environment (CABE). In January 2005 he was seconded to the Office of the Deputy Prime Minister as the Interim Chief Executive of ASC, the Academy for Sustainable Communities.

# Selected Websites

The websites listed below offer a broad range of information relating to artists' practice in public contexts. They have also been selected as useful portals, with good links to a broader range of sites.

## Contemporary Public Art Practice

**www.ixia-info.com**
ixia is the professional body for those involved in public art practice. Its website includes information on best practice, case studies, research projects, a directory and details of events.

**www.publicartonline.org.uk**
A public art resource provided by Public Art South West, offering practical advice, case studies, examples of public art policy, strategy and guidance documents, notice-board, and details of courses on public art at UK colleges.

**www.art-public.com**
A European website on public art, by subscription, offering regular case studies of public art projects across the world.

## Art, Architecture and Design Organisations

**www.culture.gov.uk**
The Department of Culture Media and Sport's website includes good links on arts funding, arts education, art and social policy, and details of government arts and culture initiatives such as the Culture Online programme.

**www.artscouncil.org.uk**
Arts Council England provides national and regional funding advice, news and information concerning the arts in England.

**www.craftscouncil.org.uk**
The Crafts Council's site includes information on exhibitions, events, education, the Crafts Council gallery and Crafts magazine and advice on buying and commissioning contemporary craft.

**www.designcouncil.org.uk**
The Design Council offers design related information and resources for schools, colleges, universities, businesses, artists and the general public.

**www.architecture.com**
The Royal Institute of British Architects provides a wide range of resources on architecture and architects.

**www.cabe.org.uk**
The Commission for Architecture and the Built Environment provides a range of services and information to those involved in the development of the built environment and related arts professions.

**www.buildingforlife.org**
Building for Life has been created by CABE, the Housebuilders Federation and the Civic Trust to advocate and support high quality design for housing schemes. The site has good links on architecture and development.

**www.artandarchitecture.co.uk**
Art & Architecture is a practitioner-led alliance promoting interaction between artists and architects to create an improved built environment.

**www.creative-partnerships.com**
Creative Partnerships is a government-funded initiative established to develop schoolchildren's creativity by building sustainable partnerships between schools, creative and cultural organisations and individuals.

**www.aandb.org.uk**
Arts and Business is a member organisation helping business and the arts to develop effective creative partnerships together.

**www.sciart.org**
Sciart aims to encourage creative and experimental collaborations between scientists and artists.

**www.nnah.org.uk**
The National Network for Arts in Health is a membership organisation for artists, consultants and commissioners. Their website includes information on arts in health projects and funding.

**www.artandsacredplaces.org**
Art and Sacred Places commissions artists to make new work in response to sacred places. Their website provides details of past projects and new commissions.

## Information for Artists

**www.visualassociations.org.uk**
An online directory of artists and art projects in the UK.

**www.a-n.co.uk**
The Artists Information Company provides information for artists through three main activities: newsletter, web and a programme supporting professional development.

**www.apd-network.info**
The Artists Professional Development Network offers an information point for 35 professional arts organisations.

**www.artifact.ac.uk**
Limelight is an arts showcase feature of Artifact, the guide to internet resources in the Arts and Creative industries.

# Selected Bibliography

The books listed below offer a selection of publications on public space and artists' practice. More detailed bibliographical information can be found on the websites listed on page 178.

## General

Doherty, Claire ed., *Contemporary Art from Studio to Situation*, London: Black Dog Publishing, 2004

ixia, *Desirable Places: the contribution of artists to creating spaces for public life*, London: Central Books, 2004

Kearton, Nicola ed., *Art and Design: Public Art*, Academy Group, 1996

Matzner, Florian ed., *Public Art: A Reader*, Ostfildern: Hatje Cantz, 2004

Petry, Michael, Nicolas de Oliveira and Nicola Oxley, *Installation art*, London: Thames and Hudson, 1994

Putnam, James, *Art and Artifact: the museum as medium*, London: Thames and Hudson, 2001

Selwood, Sara, *The Benefits of Public Art*, London: Policy Studies Institute, 1995

Stallabrass, Julian, Pauline van Mourik Broekman, Niru Ratnam et al, *Locus Solus Site, Identity, and Technology in Contemporary Art*, London: Black Dog Publishing, 2000

Wallinger, Mark and Mary Warnock, *Art for All? Their policies and our culture*, London: Peer, 2000

## Guidance on Public Art

Greene, Lesley, *Commissioning Art Works*, London: The Arts Council of England, 1996

Jones, Susan ed., *Artists Handbooks: Art in Public: What, Why and How*, Sunderland: AN Publications, 1992

## Art and Education

Sorrell, John and Frances, *Joined Up Design for Schools*, London and New York: Merrell, 2005

## Art and Science

Arends, Bergit and Davina Thackara eds., *Experiment: conversations in art and science*, London: The Wellcome Trust, 2003

Ede, Siân ed., *Strange and Charmed: Science and the Contemporary Visual Arts*, London: Calouste Gulbenkian Foundation, 2000

## Arts and Health

*Improving the patient experience—The art of good health A practical handbook*, Norwich: NHS Estates The Stationery Office, 2002

Senior, Peter and Jonathan Croall, *Helping to Heal: The Arts in Health Care*, London: Calouste Gulbenkian Foundation, 1993

## Creating Cities

*By Design—Urban design in the planning system: towards better practice*, London: Office of the Deputy Prime Minister and Commission for Architecture & the Built Environment, 2000

Florida, Richard, *Cities and the Creative Class*, London: Routledge, 2005

Florida, Richard, *The Rise of the Creative Class and How It's Transforming Work, Leisure, Community & Everyday Life*, Philadelphia: Perseus, 2002

Landry, Charles, *The Creative City: A toolkit for urban innovators*, London: Comedia and Earthscan, 2000

Murray, Chris, *Making Sense of Place: new approaches to place marketing*, London: Comedia, 2001

## Public Art Projects

*Art at the Met Office*, London: Met Office, 2004

*Further A Field, Up In The Air*, Manchester: Cornerhouse Publications, 2000

*Further A Field, Further Up in the Air*, Manchester: Cornerhouse Publications, 2003

*Further A Field, Furthermore—A Book of Proposals*, Manchester: Cornerhouse Publications, 2004

*New Art for the Historic Environment*, London: Heritage Lottery Fund, 2002

Campbell, Louise, Vivien Lovell, Richard McCormac et al, *Phoenix: Architecture Art Regeneration*, London: Black Dog Publishing, 2004

Doherty, Claire ed., *Out of Here: Creative Collaborations Beyond the Gallery*, Birmingham: Ikon Gallery, 1998

Eccles, Tom, Anne Wehr and Jeff Kastner, *Plop: Recent Projects of the Public Art Fund*, London: Merrell, 2004

Gooding, Mel, *Public: Art: Space, A Decade of Public Art*, London: Merrell Holberton, Public Art Commissions Agency, 1998

Lack, Jessica ed., *Five Spaces—New urban landscapes for Glasgow*, London: August, 1999

McLean, Bruce and Bauman Lyons, *Promenade: An architectural collaboration for Bridlington*, Beverley: East Riding of Yorkshire Council, 2001

van Noord, Gerrie ed., *Offlimits: 40 Artangel Projects* London: Merrell, 2002

# Artpoint: Past and Present

Artpoint is a creative company working with artists to support new thinking and practice for the built environment and public space.

Artpoint evolved from City Gallery Arts Trust (1982-94), a visual arts organisation based in Milton Keynes, Buckinghamshire, which focused on the commissioning of artwork for the new town.

Artpoint was formed in 1994 as a regional arts commissioning agency. The organisation moved to Oxford in 1998 and has extended its work to encompass research projects and the development of its own initiatives in addition to consultancy, project management and audience engagement activities for clients.

Artpoint now works primarily in the South East of England. Since its formation it has received funding from the Arts Council, initially from Southern Arts and since 2002 from Arts Council England, South East.

**Artpoint Staff**
Tiffany Black
Ruth Charity
Bridget Crump
Laura Dennis
Debbie Mason
Louise O'Reilly (Director)
Helen Whitehead

**Associate Project Managers**
Jane Heath
Sarah Wang
Sam Wilkinson

**Former Staff**
Catherine Crosswell
Simone Hamburg
Pauline Heffernan
Christie Johnson
Nicola Kennedy (Director 1992–2000)
Sue McMurray
Julie Roberts
Sarah Wang

**Artpoint Trustees**
Edward Allington
Ann Elliott
Taymour Ezzat
Simon Fenton
John Hoole
Vicky Hope-Walker
Chris Murray
Janet Summerton
Ken Taylor (Chair)
David Wilson

**Former Trustees**
Ian Beach
Fionnuala Boyd
Steven Crabbe
Peter Eatherley
John Fazackerley
Rosy Greenlees
Nicholas Sharp
Richard Swan

Edward Allington, *Three Doors, One Entrance* (detail), 1999, study for wall drawing in foyer and rehearsal room corridor, Milton Keynes Theatre

| | | | 1886 | | Brot forward | 268 | 1219 | 6 | 10 | | | Brot forwd | |
| 4 | 2 | 4 | July | 3 | To Goods | 467 | 60 | 2 | 8 | | | | |
| | 2 | 1 | | 9 | " " | 471 | 60 | 2 | 8 | | | | |
| | | | | 15 | " " | 478 | 60 | 8 | 2 | | | | |
| 4 | 4 | 5 | | | " " | 479 | 30 | 1 | 4 | | | | |
| | | | | | | | 1430 | 1 | 8 | | | | |
| 7 | 16 | 11 | | | | | | | | | | | |
| | 4 | | 1886 | | | | | | | 1886 | | | |
| | | | July | 21 | To Goods | 485 | 60 | 2 | 8 | Sept 22 | By Cash | | 8 |
| 8 | | 11 | | 26 | " " | 490 | 60 | 6 | 4 | " | Discount | | |
| | | | | 20 | " " | 494 | 60 | 6 | 4 | | | | |
| | | | Aug | 9 | " | 502 | 60 | 8 | 2 | | | | |
| 8 | 14 | 2 | | | | | 241 | 3 | 6 | | | | |
| | 4 | 6 | | | | | | | | | | | |

| | | | | 19 | | | | | | | | | |
| | | | | 22 | | | | | | | | | |
| | | | | 27 | | | | | | | | | |
| | | | Oct | 8 | | | | | | | | | |
| | | | | 12 | | | | | | | | | |
| | | | | 19 | | | | | | | | | |
| | | | 1886 | | | | | | | 1886 | | | |
| | | | Oct | 22 | | | | | 6 | Dec 30 | By Cash | | 10 |
| | | | | 27 | | | 08 | 17 | | " | Discount | | |
| | 9 | | | 1 | " | 02 | 59 | 17 | 2 | 28 | " Goods | 178 19 8 | 8 |
| 18 | 23 | | 17 | 4 | " | 607 | 59 | 17 | 2 | 10 | " Allowance | 13 | 24 |
| | | | | 9 | | 613 | 30 | 5 | | 1887 | | | |
| 4 | 8 | | | 11 | | 614 | 60 | | 10 | Eany 26 | " Cash | | 11 |
| | | | | 15 | | 620 | 60 | | 10 | " | Discount | | |
| | | | | 24 | | 633 | 59 | 13 | 6 | | | 204 3 10 | |
| 7 | | 8 | | 27 | | 637 | 58 | 18 | 10 | | | | |
| | 3 | 7 | Dec | 1 | | 642 | 59 | 8 | | | | | |

# Acknowledgements

© 2005 Black Dog Publishing Limited,
the artists and authors
All rights reserved

Edited by Ruth Charity
Picture research by Sandy White and
Tigger MacGregor
Designed by www.axisgraphicdesign.co.uk

*Re Views* has been published with support
of Arts Council England, South East

**ART**POINT

2 Littlegate Street
Oxford
OX1 1QT
Tel: +44 (0)1865 248822
Fax: +44 (0)1865 248899
e: info@artpointtrust.org.uk
www.artpointtrust.org.uk

Artpoint is a limited company
(registered no: 1646013) and a registered
charity (registered charity no: 285485)

■■■ **Black Dog Publishing**

Black Dog Publishing Limited
Unit 4.4 Tea Building
56 Shoreditch High Street
London
E1 6JJ
Tel: +44 (0)20 7613 1922
Fax: +44 (0)20 7613 1944
Email: info@bdp.demon.co.uk
www.bdpworld.com

Printed in the European Union

ISBN: 1 904772 20 X

Grateful acknowledgement is made to the
following for permission to reproduce
material:

p. 13 The Corporation of London
p. 16 Artangel
p. 34 The Royal Collection
p. 36 (below) The River and Rowing
Museum, Henley
pp. 22-24 Kodansha International
p. 25 Estate of Robert Smithson
p. 62 (top) Common Ground
p. 73 (left) Lisson Gallery and Richard Long
p. 73 (right) Leeds Museums and Galleries
pp. 84,88,95 (below) Winchester City Council
p. 97 Weald and Downland Open Air
Museum, Chichester
p. 104 Swindon Evening Advertiser
p. 105 (top) King Alfred's College,
Winchester
p. 108 Arts Catalyst
p. 117 atelier one
p. 119 Lisson Gallery
p. 120 Tate Gallery
pp. 124,131 (top and below),132 (top),133
(below),136 (below),137,138 Ellis Williams
Architects
p. 149 English Partnerships, with the kind
assistance of the Commission for the New
Towns (operating as English Partnerships)
p. 162 New East Manchester Ltd

**Photographic credits**

All photographs are reproduced courtesy
the artists and Artpoint, except where
stated otherwise:

Cover and pp. 3,95 (top),142,144
(below),148,150 Paul Carter
p. 10 Bruce Williams
p. 13 (left) Mike Slocombe
p. 16 Martin Jenkinson
p. 17 Andy Hewitt and Mel Jordan
p. 19 Thomas Eisl
p. 20 Klaus-Josey Rossfeldt
p. 48 Raissa Page
p. 50 Paul Seawright
pp. 54,57,58 (below),59,87,89 (top),93
James Newell
p. 61 (top) Robin Gillanders
p. 61 (below right) Woodley & Quick
p. 62 (below) Michael Myers
pp. 66, 67 Chris Chapman
pp. 70,74 (below right),77 Ruth Charity
pp. 78 (top),133 (top) Helen Whitehead
pp. 78 (below), 79, 80 (top) Richard Layzell
p. 80 (below) Anne Koerber
p. 89 Adam Lawrenson
p. 95 (below left) Tony Langridge
p. 96 Ian Britton
p. 97 Louise Burston
p. 104 Matthew Swingler
p. 107 David Pearl
p. 108 Andrew Holligan
p. 109 Carole Waller
p. 115 (below) Bridget Crump
p. 116 Jem Finer
p. 118 Etienne Clément
p. 119 John Riddy
p. 120 Marcus Leith
p. 128 (below) Susanna Heron
p. 130 (below left) Andrew Whittuck
p. 130 (below right) Edward Woodman
p.147 (top) Sue Ormerod
p.151 Keith Hunter
pp. 160,161 Steve Speller
p. 162 Len Grant
pp. 164,165 (top) Mark Pinder
p. 166 Jerry Hardman-Jones
p. 167 Rocco Redondo